D1489544

THE ART OF LANGUAGE

DISCOVER 26 HAND-LETTERED SCRIPTS FROM AROUND THE WORLD

语言的魅力

CONTENTS

INTRODUCTION

It's a great loss that, no matter how open we are to new and interesting sights and sounds and tastes when we travel, oftentimes our attitude toward writing is completely different.

As soon as we leave the Latin-alphabet world, we feel lost, frustrated, anxious. It doesn't matter how elaborate or graceful the local script is: we stare at it, not even able to turn letters into sounds, thinking, *Just tell me how to get to the darn railway station.*

I admit, I was just as uncomprehending and impatient when faced with non-Latin scripts until, quite by chance, I started carving the world's rarest and most endangered scripts in wood. (Brief note of explanation: I'm not a linguist by training, nor even a wood-carver. I'd just stumbled across some of these – to me – exotic and astounding scripts and learned that perhaps 85 percent of the world's alphabets are on the verge of extinction. So I decided to preserve a few in wood. As one does.) After a year or so of this, I founded the Endangered Alphabets Project, with the goal of helping indigenous and minority cultures revitalise their traditional scripts, some of which have been in use for over a thousand years.

In the process I discovered – as you will, by reading this book – some things about writing. From the get-go, I was fascinated by the enigmatic shapes of the letters and words themselves. It was like puzzling over the vast bluestones at Stonehenge: you can tell they have shape, design, purpose – but you can't work out what it is. In less commonly used scripts, it's an intriguing mystery to unravel; in others, robust communities of millions of native speakers (and readers) exist to teach best practices and model usage.

As I got curious about why the scripts had evolved the way they had, I discovered their stories are as compelling as their mystery: the man who was assassinated for bringing literacy to his people; the alphabet whose every letter has a secret mystical meaning; and the culture that esteems writing so highly that if someone dies without learning to read and write, the priest teaches those skills to the corpse so it can pass successfully into the afterlife.

Each culture's script is an expression of that people's history, its religion, its tools, its experience of wars won and lost – even its flora and climate, for writing on palm leaves produces a vastly different script than incising writing into bamboo. As this book will show you, writing is like a slow-growing local plant whose roots are astonishingly deep. A traveller who ignores local writing is missing as much as one who ignores local architecture.

Consequently, I came to realise that writing conveys a great deal more than sound and meaning. The very shapes of the letters are part of the landscape. A culture's traditional script may be as beloved as its flag, even when nobody can still read it. And as this book shows, many scripts have managed to thrive in our information age even as Latin letters have overtaken others. We should celebrate their success and engage with them.

Soyombo, one of the scripts invented to write Mongolian, has not been generally used for more than a century, yet it is so deeply part of the country's identity that a Soyombo letter is front and centre in the

© Tim Brookes

Right: a carving that reads 'Everything happens for a reason', based on the Tibetan calligraphy of the Buddhist monk Tashi Mannox.

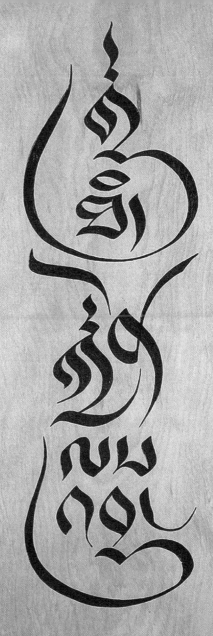

country's official seal. Nobody uses the Glagolitic script any more, but there are at least two sculpture trails in Croatia that wind between vast stone Glagolitic letters, as if Croatia were the Easter Island of Eastern Europe. Adinkra symbols are literally woven into (and printed on) fabrics in Ghana, and one of the most popular tattoo designs in Bali is the om symbol in the beautifully fluid but endangered Balinese script.

If you practise the calligraphy exercises offered in this book, you may realise something arguably even deeper about writing. Writing is an expression of its cultural origins, but the act of writing is an extension of the body, of the turn of the human wrist. It's a form of grace, almost a dance. When I lecture on the Endangered Alphabets I have the audience trace a single Balinese letter in the air, with the tip of their index finger. And it dawns on them: the movements of their hand are the gestures of a Balinese dancer.

Expanding your knowledge of the world's non-Latin scripts, and your love of practising them, is inherently empathetic. It immediately breaks down that 'Why can't everyone else be like us?' mentality. It may not help you find the railway station, and you may, in fact, miss your train copying down an ordinary piece of street signage, in all its complex, sinuous beauty, into the pages of your travel journal.

But that's why we travel, isn't it?

TIM BROOKES
THE ENDANGERED ALPHABETS PROJECT
BURLINGTON, VERMONT

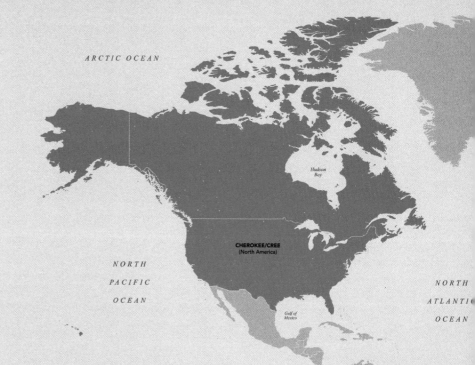

SCRIPTS
PER CONTINENT

AFRICA
Arabic (p8), Ge'ez (p52), N'Ko (p96), Tifinagh (p116), Vai (p120)

ASIA
Bengali (p18), Burmese (p22), Chinese (p30), Cyrillic (p40), Devanagari (p46), Hangul (p64), Hanuno'o (p68), Japanese (p76), Kawi-Javanese (p82), Khmer (p88), Mongolian (p92), Tamil (p104), Thai (p108), Tibetan (p112)

NORTH AMERICA
Cherokee (p26), Cree (p36)

MIDDLE EAST
Arabic (p8), Hebrew (p72), Syriac (p100)

EUROPE
Armenian (p14), Cyrillic (p40), Georgian (p56), Greek (p60)

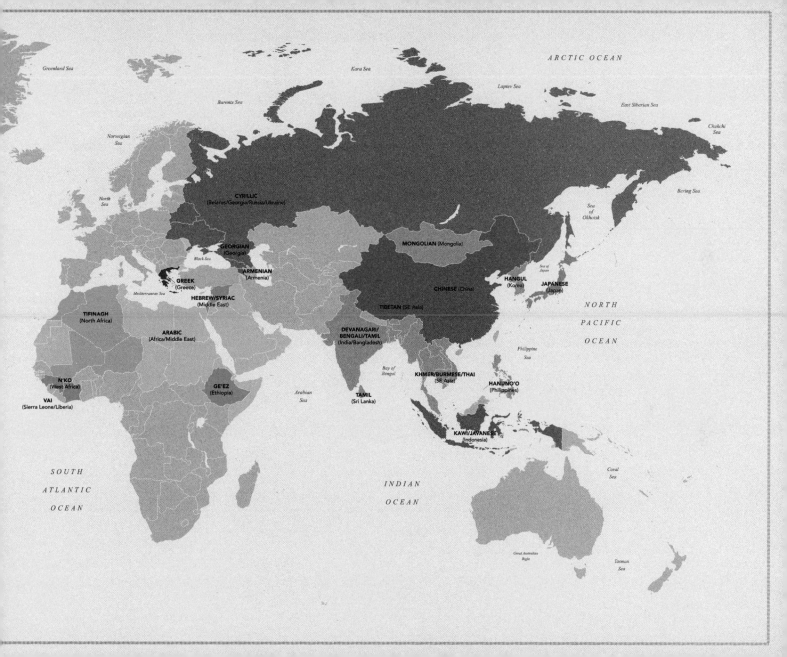

ARCTIC OCEAN

Greenland Sea

Kara Sea

Laptev Sea

East Siberian Sea

Barents Sea

Chukchi Sea

Norwegian Sea

Bering Sea

North Sea

CYRILLIC
(Belarus/Georgia/Russia/Ukraine)

Sea of Okhotsk

GEORGIAN
(Georgia)

Black Sea

MONGOLIAN (Mongolia)

Sea of Japan

ARMENIAN
(Armenia)

GREEK
(Greece)

HANGUL
(Korea)

JAPANESE
(Japan)

HEBREW/SYRIAC
(Middle East)

CHINESE (China)

Mediterranean Sea

TIFINAGH
(North Africa)

NORTH

ARABIC
(Africa/Middle East)

TIBETAN (SE Asia)

PACIFIC

**DEVANAGARI/
BENGALI/TAMIL**
(India/Bangladesh)

Philippine Sea

OCEAN

Arabian Sea

Bay of Bengal

KHMER/BURMESE/THAI
(SE Asia)

N'KO
(West Africa)

GE'EZ
(Ethiopia)

HANUNO'O
(Philippines)

VAI
(Sierra Leone/Liberia)

TAMIL
(Sri Lanka)

KAWI/JAVANESE
(Indonesia)

SOUTH

Coral Sea

ATLANTIC

INDIAN

OCEAN

OCEAN

Great Australian Bight

Tasman Sea

ARABIC

WHO & WHERE

The third-most-common writing system in the world, after the Latin alphabet and Chinese characters, is Arabic script. Its vast reach reflects that of Islam, which starting in the 7th century spread the holy Arabic text of the Quran along with the more workaday Arabic of trade and record keeping. Scores of languages adopted Arabic writing and developed variations on the alphabet. Persian, Dari and Urdu use a version with additional letters and a distinct style, while some African languages such as Mandinka, Hausa and Swahili are sometimes written in a system called Ajami. In Southeast Asia, an Arabic-based script called Jawi is used for Malay, and even farther east, for Tausug in the Philippines. As a result, while the Arabic language is spoken by about 300 million people worldwide, the Arabic script is used by more than double that amount: approximately 660 million people.

Arabic letters have their roots in Phoenician, by way of Syriac and Nabataean. The earliest known inscriptions are thought to be from the 3rd or 4th century AD, found in what is now Jordan and Saudi Arabia. At first, letter forms were limited, and used only to aid recall of oral poems or trade agreements. The system was made fully phonetic – one letter for one sound – in order to reproduce the Quran, considered the literal word of God, with the utmost precision. That phonetic quality is somewhat hypothetical, however, as Arabic is highly diglossic – that is, the written language (called *fusha*, 'eloquent') is markedly different, in both pronunciation and structure, from its many spoken dialects.

Typically, Arabic is spelled according to 'true', historic pronunciation – but informal writing, in text messages and online, is increasingly spelled as spoken, and sometimes this shows up in commercial slogans and political ads.

As iconography was disfavoured in Islam, calligraphy developed as one of the empire's principal decorative arts, with graceful Arabic letters adorning manuscripts as well as monumental buildings. During the Ottoman Empire, Istanbul took up the mantle of Islamic culture, and the city is still considered the capital of Arabic calligraphy – even after 1928, when Kemal Atatürk decreed that Turkish be written in Latin letters. Arabic typeface design, a more recent creative endeavour, flourishes especially in Beirut, building on the legacy of Maronite monks who imported the first printing press to the Middle East in 1610.

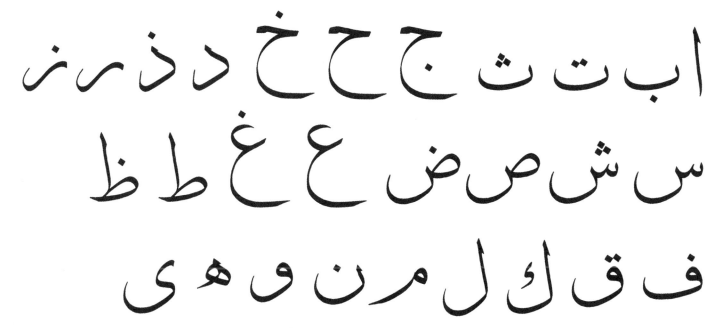

HOW TO USE IT

Strictly speaking, Arabic is not an alphabet but an abjad, the term for systems in which vowel notation is limited. Written right to left, the abjad has 25 consonants and three long vowels, two of which double as consonants (*oo* and *w*; *ee* and *y*). All short vowels are indicated with small symbols called *harakat* (motions) above and below the letters – in theory, at least. In practice, the *harakat* are used only in children's books and the Quran. A good Arabic reader can differentiate identical combinations of consonants from context: Without vowel marks, the letters ت, ك and ب, for instance, can represent a verb, kataba (he wrote), or a noun, kutub (books), while the letters ع, ش and ر together could mean 'poetry' (pronounced sha'r) or 'hair' (shi'r).

In its earliest form, Arabic was carved in stone, and letters had a somewhat angular shape even when later written with a reed pen on parchment. When paper was brought to the caliphal court in Baghdad in the 8th century, the smooth new writing surface inspired more flowing shapes, including the concise writing style called *naskh* (copying), used for many of the translations and texts produced during the Islamic Empire's golden age, as well as copies of the Quran. This fundamental style and the graceful *thuluth* ('one-third', used above and, more elaborately, on p12) were standardised by a vizier in the Baghdad court, Ibn Muqlah, who established rules still used today, in which the letter's size is proportional to that of the dots made by the reed pen tip. He also, according to legend, kept working on his art even after losing a hand as punishment for court intrigue.

End	Middle	Beginning	Stand-alone

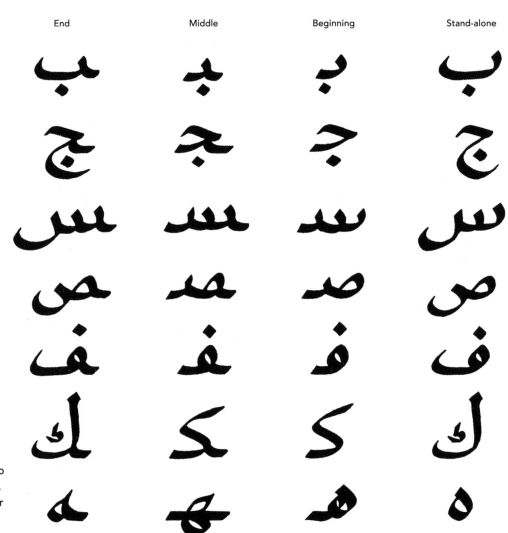

LETTER FORMS

Arabic is fundamentally a cursive writing system: letters almost always connect to their neighbours. Each letter can have up to four different forms, depending where it falls in the word. The table here shows, from right, the stand-alone, beginning, medial and final forms of several letters. The most typical transformation is that letters with long descenders lose their 'tails' when they connect. In some cases, medial letters are truncated to a single 'tooth' plus the requisite dots. Workaday handwriting allows some shortcuts: two dots become a short horizontal line, for instance, and three dots become a caret. Young students practise handwriting on a baseline, but the ideal style is for letters to be written on a slight slope. In calligraphy, this is called *ta'liq* (suspension): each letter hangs slightly below the preceding one.

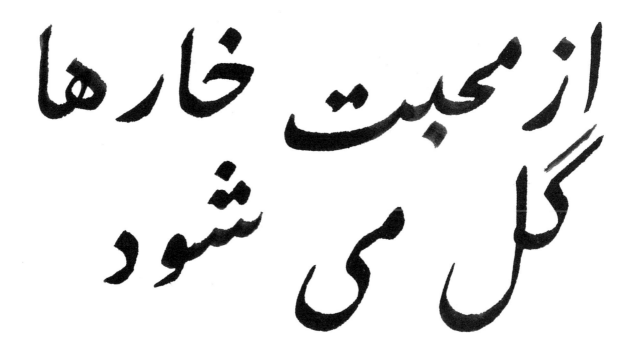

PERSO-ARABIC

The most widely used variation on the standard Arabic alphabet is Perso-Arabic, with versions for Persian and Urdu used by almost 180 million speakers combined. Additional letters are usually built with more dots: *p* (پ), for example, is from Arabic *b* (ب). Urdu's retroflex *r, t* and *d* (pronounced with the tongue curled back) are marked with a miniature ط above some letters. Perso-Arabic is typically written in a steeply sloping style called *nasta'liq*, shown here in a verse by the poet Rumi. In Pakistan, devotion to the style is so strong that many newspapers were written by hand, by master calligraphers, as late as the 1980s, when modern word processing finally enabled all the complex ligatures. Chennai, India, is home to the last handwritten daily Urdu paper, published since 1927.

PROVERB

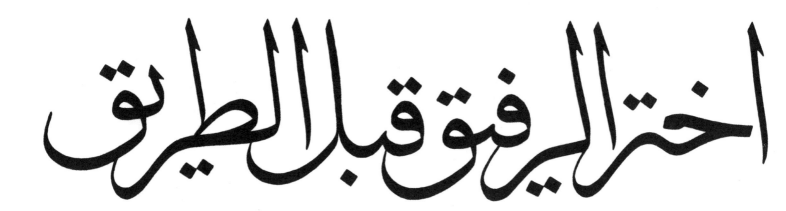

اختر الرفيق قبل الطريق

CHOOSE YOUR COMPANION BEFORE YOUR ROUTE.

TRY ON THIS PAGE

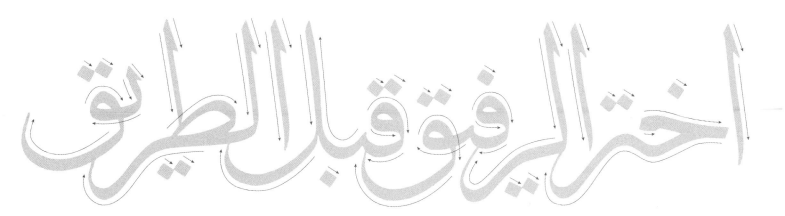

CALLIGRAPHY TOOLS USED:
Bamboo pen with a handcut broad edge tip (nib).

ARMENIAN

WHO & WHERE

Few people are prouder of their alphabet than Armenians, and few Armenians are esteemed as highly as Mesrop Mashtots, the polymath monk and Orthodox saint credited with inventing the alphabet in 405 AD. More pious people consider the early linguist not so much an inventor as a vessel of a divine message from God; the alphabet, they point out, begins with a for *Astvats* (God) and ends with k' for *K'ristos* (Christ).

Noble-born Mashtots served as a secretary in the Sassanid Persian court, where he wrote in Greek and Pahlavi (the script used for Persian before it switched to Arabic letters), and he likely drew on both writing systems when he constructed the Armenian alphabet. As in Greek, Armenian letters represent distinct consonants and vowels, rather than syllables. Some Armenian letter forms resemble Aramaic, Pahlavi's parent system.

This fusion of systems mirrored Armenia's geographical position, between Byzantium to the west and Persia to the east. In prior centuries, the Armenian language was written variously in Greek,

Syriac and Aramaic. Mashtots' alphabet gave the Armenians a visible symbol of identity, which helped preserve their culture and history when it could easily have been trampled by rival armies.

It is possible that Mashtots was inspired more by Earth than heaven, as there are some hints of a pre-Christian Armenian writing system, and the pagan pantheon included a god of science and writing. Whatever the case, very soon the Bible was translated into his new alphabet (overdue, considering the Kingdom of Armenia was the first to accept Christianity as a state religion, in 301 AD), as was the Orthodox liturgy. Many classical Greek works were translated too; a few were preserved through the Middle Ages only in Armenian. In later centuries, the Armenian alphabet was used to write Kipchak, a now-extinct Turkic language that spread as far west as Hungary. The first Turkish-language novel, in 1851, was written in Armenian letters – but the alphabet has not been used in Turkey since 1950. Today some 6.7 million people in Armenia and the diaspora write with Mashtots' letters.

Աա Բբ Գգ Դդ Եե Զզ Էէ Ըը Թթ

Ժժ Իի Լլ Խխ Ծծ Կկ Հհ Ձձ Ղղ

Ճճ Մմ Յյ Նն Շշ Ոո Չչ Պպ Ջջ

Ռռ Սս Վվ Տտ Րր Ցց Ււ Փփ Քք

Օօ Ֆֆ և

HOW TO USE IT

Following the pattern established by Greek, Armenians refer to their alphabet as the *aybuben*, after its first two letters. In total, there are 38 letters, plus a symbol for 'and' (an ampersand). They have both upper- and lowercase forms, and writing runs left to right. Aside from the addition of two letters in the medieval period, and some minor spelling reforms in the 1920s under the Soviets, the alphabet has remained remarkably consistent over the past 1600-plus years, and for the most part it is an accurate phonetic representation of Armenian speech. The one exception is that it has no symbol for the schwa, the shortest neutral vowel, so Armenian words can often have up to six consonants in a row, and only native speakers know instinctively where to insert vowels.

Armenian was first written on parchment, and later on paper, with both quills and reed pens. Old Armenian manuscripts are distinguished by their vivid red ink, derived from an insect found in the Ararat Valley. Traditionally students practised writing the same words that Mashtots is said to have first rendered in Armenian, a phrase from the Book of Proverbs: 'To know wisdom and gain instruction; to discern the words of understanding'.

PROVERB

Հաց ու պանիր, կեր ու պարիր:

BREAD AND CHEESE, EAT AND DANCE.

TRY ON THIS PAGE

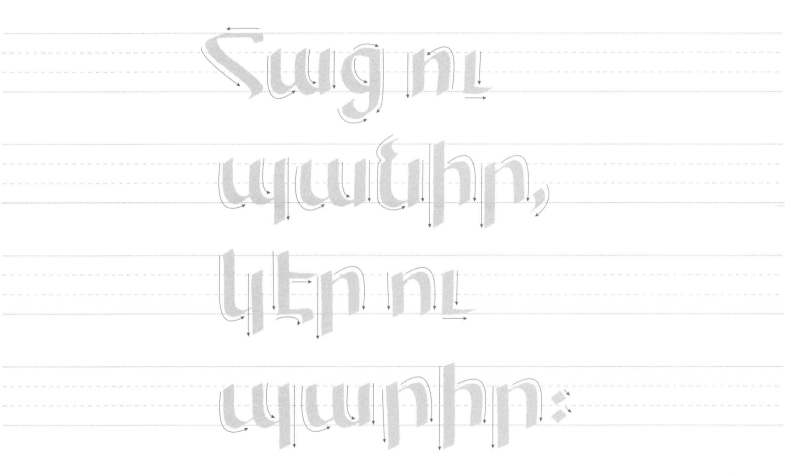

CALLIGRAPHY TOOLS USED:
Black non-waterproof ink and Pilot Parallel Pen 3.8mm

BENGALI

WHO & WHERE

South Asia has a diverse language ecosystem, and one major branch within the Indo-Aryan family is Bengali, or Bangla. Close to 275 million people in India and neighbouring Bangladesh use *bangla lipi* (Bangla script) to write the Bengali language, as well as Assamese, Sylheti and Manipuri (also called Meitei). In fact, it is by most estimates the world's fifth-most-used writing system – just after Devanagari, to which it is related.

Bengali script – sometimes referred to as Eastern Nagari, although this is technically a predecessor of the modern script – developed over several centuries in the eastern part of India, where it was used to write Sanskrit and many other languages between the Himalayas and the Bay of Bengal. By the 11th century, it became the recognisable system it is today, and over the two hundred years of the Islamic kingdom of the Bengal Sultanate, beginning in 1335, it came to be associated primarily with the Bengali language.

Later, Bengal lost its independence and was ruled at a distance, via edicts in Arabic, Hindi and English. In the late 19th century, a movement began to promote the Bengali script and language – most famously through the work of poet Rabindranath Tagore, who won the Nobel Prize for Literature in 1913 for his works in Bengali. The movement crystallised in 1947, when partition created the state of Pakistan, two noncontiguous provinces on either side of India. Immediately, leaders in the new nation's capital of Karachi moved to make Urdu, spoken in West Pakistan, the sole state language, over the protests of some 44 million Bengali speakers in East Pakistan (later to become Bangladesh). Despite Bengali speakers' majority, Karachi politicians insisted 'Urdu, and only Urdu' would unify the new Muslim nation, because Urdu was written in the same script as Arabic, the language of the Quran. Even a compromise of writing Bengali in Arabic script was denied.

On 21 February 1952 the military used lethal force to put down University of Dhaka student demonstrations against the Pakistani government's language policy, and massive unrest followed. Finally, in 1956, Bengali was ratified as a second official language – but by then the rift was too deep, and in 1972 Bangladesh became an independent country. 21 February is now a national holiday in Bangladesh, honoured as Language Movement Day, and in 1999, UNESCO named the date International Mother Language Day.

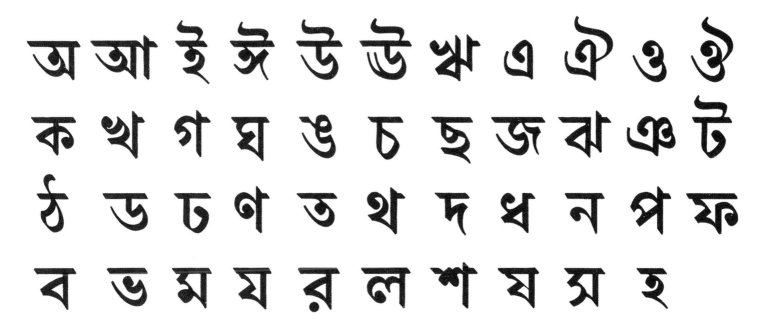

HOW TO USE IT

Like many other scripts of South Asia, Bengali is an alphasyllabary, also known as an abugida. That is, each consonant symbol has an inherent vowel (o, in this case); other vowels are represented with stand-alone letters or, more commonly, diacritics that are placed below or on either side of the consonant. Writing runs left to right, with no capital letters.

The writing system was standardised in the 1800s, when teacher and writer Ishwar

Chandra Vidyasagar tailored the script to better fit Bengali. He reduced the set of letters, removing many that were used primarily for Sanskrit, and devising three new ones to reflect Bengali pronunciation. The script now has 11 vowels (the top row above) and 32 consonants (the remaining three rows).

Bengali consonants can combine into one grapheme (a single written symbol), compressed into a kind of invisible rectangle

– much the same way Chinese characters are written in an implicit square. Sometimes these combined consonants are clear, but there are also many irregular combinations, which means a bit more to memorise; the total set consists of about 350 shapes. In some Bengali writing, the spaces are very small, but you can generally distinguish between words by looking for the breaks in the matra – the headline that connects graphemes. A vertical line marks a full stop.

PROVERB

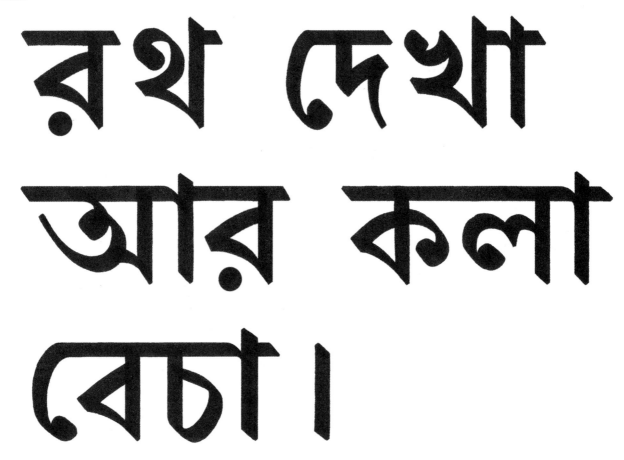

রথ দেখা আর কলা বেচা।

SEE THE FESTIVAL AND SELL THE BANANAS.

TRY ON THIS PAGE

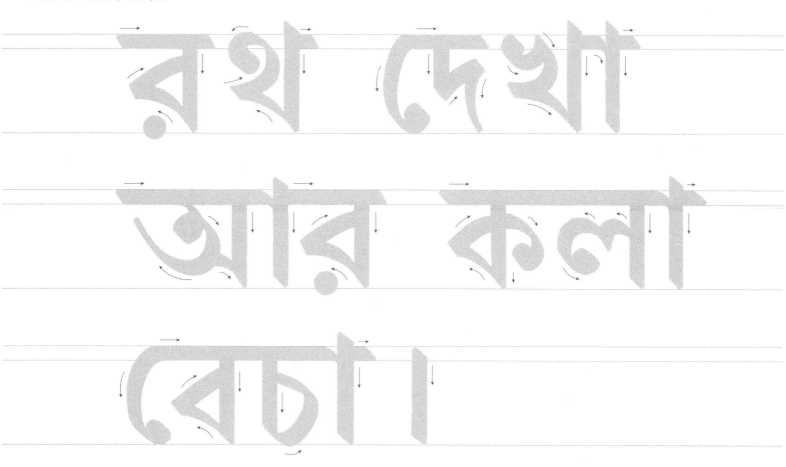

CALLIGRAPHY TOOLS USED:
Chisel tipped marker pen (25-30 degree slant)

BURMESE

WHO & WHERE

Burmese script is part of the South Indic group, derived from ancient Brahmi script. All of the South Indic scripts are markedly curvier than those in the North Indic branch – and Burmese, with its perfect circles, is the curviest of all. So-called *ca-lonh* (round script) grew from an earlier style of round, thick letters with a flat bottom edge, aptly named 'tamarind-seed script'. Its immediate predecessor is probably now-disused Old Mon, which for centuries was the dominant script and lingua franca around the course of the Irrawaddy River. The oldest known Burmese inscription dates from 1113, on a stupa in the ancient royal capital of Pagan (now Bagan).

Eventually the Bamar people – and their Burmese language – came to dominate what's now Myanmar, squeezing out Old Mon. Burmese script is used for the Burmese language across the country, and modified versions are used for contemporary Mon as well as for Shan, Karen and several other minority languages, which are also found in a few small pockets of Thailand, Sri Lanka, Laos and Cambodia. Around 42 million people use variations on the script.

Theravada Buddhist scripture, in the ancient language of Pali, is also written in Burmese letters. Monks practise by copying excerpts from the *Pali Canon*, Theravada's standard collection of texts, and assembling them into a book called a *kammavaca*. In 1868 King Mindon Min took the *kammavaca* to a new level by ordering the sacred texts written not on the traditional palm-leaf paper, but inscribed on 729 5-foot-high marble slabs, each installed in its own stupa.

The collection, dubbed the world's largest book, adjoins Kuthodaw Pagoda in Mandalay.

Burmese writing has faced a special challenge in the digital era. A freeware font system, Zawgyi, took over the market in Myanmar during the military junta period, while the rest of the world followed the international-standard Unicode system. The conflicting sets of code produce incomplete search results online, as well as garbled text rendering, but Zawgyi is embedded in most phones and other tech sold in the country. Compounding the issue: Zawgyi represents only 'true' Burmese letters, and not the additional symbols for Mon, Karen and other minority languages included in Unicode. In nearby Cambodia, Khmer resolved a similar technological conflict only through government regulation.

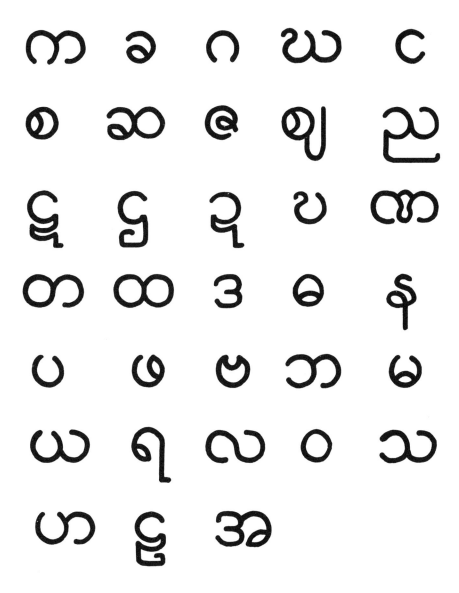

HOW TO USE IT

Like all Indic scripts, both North and South, Burmese is an abugida. It consists of 33 consonants (shown here), each with the inherent vowel *a*. Because Burmese is a tonal Sino-Tibetan language, however, and the script is most likely borrowed from non-tonal, Afro-Asiatic Mon, the writing system also requires a complex web of 17 additional symbols to capture the nuances, especially in its vowel sounds.

Although text is read left to right, writing a word can involve moving the pen in all directions, as symbols are set above, below and on either side of consonants. Or a symbol can almost completely enclose a letter, as in the case of the *ya yit*, a rectangular frame that can alter the sound of a consonant, changing a *k* to a *kr*, for instance. The symbols' placement also depends on other consonants, which are combined in a vertical stack when they are not separated by a vowel.

Children begin to learn about this complex system through the simplest of shapes: the letter *wa*, a small circle. This in turn is the basis of nearly all of the other consonants. Calligraphers are taught to hold their brushes perfectly vertically, and may even use a compass to produce a flawless circle. For a long time, calligraphy was done on native palm leaves rather than paper, and monasteries would create manuscripts on the leaves.

PROVERB

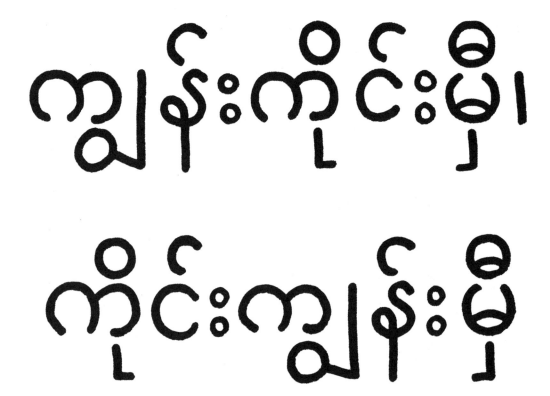

ISLANDS RELY ON REEDS JUST AS REEDS RELY ON ISLANDS.

TRY ON THIS PAGE

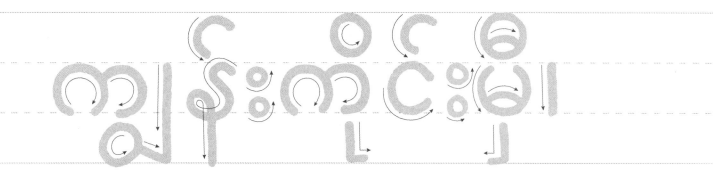

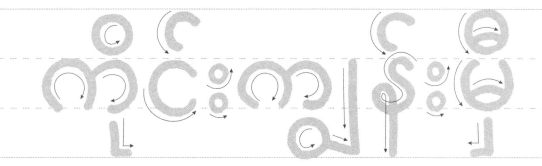

CALLIGRAPHY TOOLS USED:
Sumi and Speedball B-2 nib

CHEROKEE

WHO & WHERE

One of the most influential scripts of the last two centuries was invented not by a linguist or a scholar, but by a blacksmith who did not read in any language – at least not at first. Born in Tennessee around 1770, Sequoyah, also known as George Gist, was impressed by the 'talking leaves' (meaning letters) that white men used to communicate over long distances. So he set out to develop a similar system for his native Cherokee.

Sequoyah worked for a wasted decade on an unwieldy system of logograms, but eventually had the breakthrough of dividing words into syllables. Over about a month in 1821, he devised a set of characters, which he taught to his six-year-old daughter, Ayoka. Together they demonstrated the script to Cherokee from Georgia to Arkansas. Sequoyah would ask each elder to say a word, which he would write, then summon Ayoka to read the words aloud. Doubters accused him of sorcery or simply assimilation, but he's said to have insisted, 'The white man is no magician'.

In 1825, the Cherokee Nation adopted the syllabary and wrote its bylaws in it. A few years later came a constitution and the weekly *Cherokee Phoenix* newspaper, in Cherokee and English. Soon the Cherokee people's literacy rate equalled that of their white neighbours. In the 1830s, as the federal government pressured Native Americans to move west, the syllabary was cited as evidence that the tribe was, according to white supporters, 'advancing' and 'deserved' to stay on its land. To no avail: in 1838, 20,000 Cherokee were force-marched to Oklahoma, the tribe's present home. Sequoyah died in 1843, on a trip to teach his script to a far-flung group of Cherokee in Mexico.

Sequoyah's legacy is far-reaching. His syllabary certainly inspired Cree syllabics in Canada (which in turn inspired a system in China), and possibly some scripts in West Africa. His cabin in Sallisaw, Oklahoma, is a designated Literary Landmark, and the giant redwood, *Sequoia giganteum*, bears his name. As for the Cherokee language, it's still spoken by about 22,000 people and is one of the few remaining Iroquoian languages not to be critically endangered – thanks in part to two centuries of literacy.

D R T Ꮰ Ꮻ Ꭲ Ꮝ Ꭷ Ꮑ Y A

Ꭻ E Ꮸ Ꮲ Ꭱ Ꮄ Ꮖ Ꮺ W Ꮪ Ꮅ

Ꮆ Ꮇ Ꮤ Ꮦ Ꮹ H Ꮾ Y

Ꮎ Ꮧ Ꮐ Λ Ꭽ Z Ꮗ Ꮕ

I Ꭾ Ꮍ Ꮵ Ꮴ Ꭶ Ꭼ Ꭰ Ꮸ

Ꮭ Ꮼ Ꮝ R Ꮣ W Ꮬ Ꮿ Ꮷ Ꭻ

V S Ꮝ Ꮶ Ꮭ L C Ꮵ Ꮵ Ꮲ

Ꮆ V Ꮶ Ꮶ Ꭻ C Ꭿ Ꮭ Ꮎ

Ꮕ Ꮧ Ꮾ Ꮜ Ꮗ Ꭿ Ꮐ Ꭴ B

HOW TO USE IT

The Cherokee syllabary consists of 85 characters. Sequoyah's original version had one more symbol (now obsolete) and was handwritten in elegant loops and curls that looked a bit like old-style English penmanship. The system used now, however, is almost entirely different.

There's no record of why the syllabary changed so drastically, but one plausible reason is that Sequoyah found that his first system could not easily – or at least cheaply – be adapted for use on a printing press. So it's possible that he devised the new syllabary, in which many letters resemble Latin or Greek letters or numerals, because these were what a printer would have had available, and been able to modify with additional bars or serifs.

This printed system sacrificed a little clarity – the two *W* shapes, for example, can give students some trouble, as can the fact that 'familiar' English letters have completely different sounds in Cherokee. But it did enable Cherokee to spread widely and quickly through newspapers and other printed material.

For a time, both the script and printed versions were in use, but now the print set is what's taught in schools, both for handwriting and printing. Writing runs left to right, and capital letters, not consistently used, are simply larger versions of standard letters.

PRAYER

ᏚᎦᎦᎯ ᏴᎯᏉᎢ ᎣᎢ
ᏴᎯᏝᏏ ᏲᏉᎯ ᏴᎲᎢ
ᏕᏝᏉᏁ ᎤᏴᎯᏥᏉᏌ
Ꮝ ᏣᏝᏪᏁ

SKY OUR GRANDFATHER, SUN OUR GRANDMOTHER, EARTH OUR MOTHER,
I AM THANKFUL YOU LOVE US. WE ARE ALL THANKFUL.

TRY ON THIS PAGE

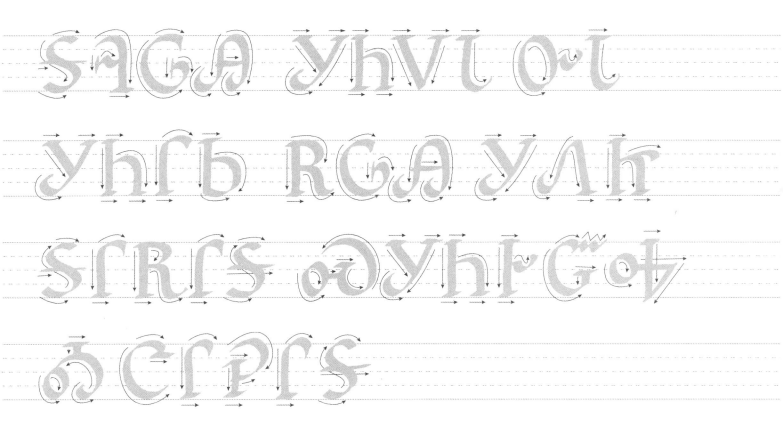

CALLIGRAPHY TOOLS USED:
Black non-waterproof ink and Pilot Parallel Pen 3.8mm

CHINESE

WHO & WHERE

Logograms – symbols that represent whole words – are the oldest known kind of writing, used in Egyptian hieroglyphics and Mayan texts. Chinese is the only ancient image-based system that has survived – and thrived. With an estimated 1.34 billion users, Chinese writing is the second most common system in the world, after the Latin alphabet. Chinese characters are used to write not only widely divergent dialects of Chinese, but also the Zhuang languages (related to Thai) in southern China. Part of the Japanese writing system is a modified set of Chinese characters, and until the late 19th century, the Korean and Vietnamese languages were written in Chinese characters as well.

The earliest known Chinese writing, from the middle of the second millennium BC, is found on 'oracle bones', animal bones inscribed with wishes and spells. These early symbols were literal: pictograms of a simple sun, a mountain, an arrow pointing up or down. This system started to expand when writers played a kind of visual game, using a literal character to stand in for a different word with a similar sound. In this way, the character system shifted from purely logographic – one word, one image – to phonographic as well: a symbol could stand for both a sound and a concept.

Over the millennia, this has enabled figurative expression – the characters for 'black' and 'heart' together mean 'ruthless', for example – as well as adaptation to new concepts. Many of the Chinese names for elements are built from a character that indicates the quality of the element – metal (the 'gold' character), say, or solid ('stone') – with another character that suggests pronunciation.

In general, the logographic system is hazy on pronunciation – and it gives no indication of tone, which is essential to distinguishing Chinese words. Another problem is the proliferation of characters. Functional literacy requires memorising between 3000 and 4000 characters; a very good reader can recognise about 6000, while some dictionaries contain up to 56,000. Characters are also tricky to print and type. One solution is the 24-character Cangjie keyboard, with which it's possible to 'build' most characters. For quick text communication, many people use the official Romanisation system, Pinyin (spelled sounds), typing Latin letters then selecting the appropriate character, or the Taiwanese phonetic system Bopomofo, named for the first four of its 37 symbols.

人 手 火 下 虫 足 一 八 禾 母
口 日 金 大 耳 走 十 寸 门 白
土 月 刀 小 田 马 方 尺 子 黑
女 木 上 力 石 牛 页 山 斤 里
心 水 中 又 衣 羊 米 文 父 甘

HOW TO USE IT

First carved in bone and stone, Chinese characters changed dramatically when they came to be written in ink. Around the 3rd century BC they took on their now-familiar square shape, and in the process became more abstract. Writing was more systematically done in vertical columns, top to bottom and left to right across the page. Although the older, non-square logograms – collectively called 'seal script', for the style used on official stamps – are still used to convey 'old-time' style in restaurant logos, they are not legible to most people.

Schoolchildren in China learn the Table of General Standard Chinese Characters, a government-reviewed set of 8105 characters. (Fifty of the most common, from 'person' to 'sweet', are shown here.) The set is also known as Simplified Chinese, because some characters have been streamlined for ease of writing and consistency. For reasons both political and sentimental, Chinese writers

in Taiwan and the diaspora typically use the older, unmodified characters, commonly referred to as Traditional Chinese. Some people avoid this label, so as not to imply the characters are old or out-of-date. Despite standardisation, rare characters still pop up and force creative solutions. Brush calligraphy and flowing handwriting are highly valued and widely taught. The traditional tools are an animal-hair bamboo brush, a solid stick of ink and an inkstone for mixing it with water.

31

人 亻 休 信 仁

水 氵 沙 海 泳

禾 禾 和 利 香

青 请 情 清

里 理 埋 野

RADICALS

Because there is no alphabet to provide an alphabetical order, Chinese dictionaries and filing systems are organised by radicals, or the building blocks of characters. The standard set, called Kangxi for a dictionary published in 1716, consists of 214 characters organised by the number of strokes. Typically, though not always, a character's radical is its left- or topmost element.

Radicals are often derived from common characters. In the top row, reading left to right, the character for 'person' yields a more vertical radical, which in turn is part of the characters 'rest', 'trust' and 'humanity'. Or a radical can be a simple character on its own, such as 'inside', on the bottom row. It's the second radical in 'reason' and 'bury', and the first in 'wild'.

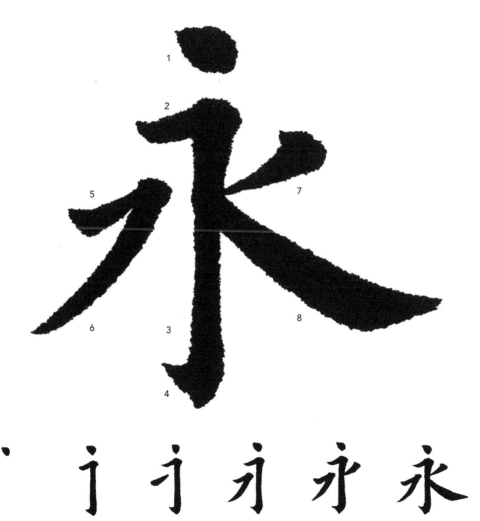

STROKE ORDER

Handwriting based on brush calligraphy is highly valued and taught early in schools. One typical student practice is the Eight Principles of Yong: the character *yǒng* (forever), which contains the eight most common shapes. To have good form, strokes should not be thin and lifeless, but have 'bone and flesh'. The order in which each stroke is written is also important and standardised, typically with vertical elements first. One way this is taught is by building a character, stroke by stroke, in successive squares – a bit like a movie storyboard. Even some frequently used characters can be complex: 蠢 (*chǔn*, 'stupid') requires 21 strokes, for example. On the upper end, *biáng*, a type of noodle in Shaanxi province, requires 56 strokes.

PROVERB

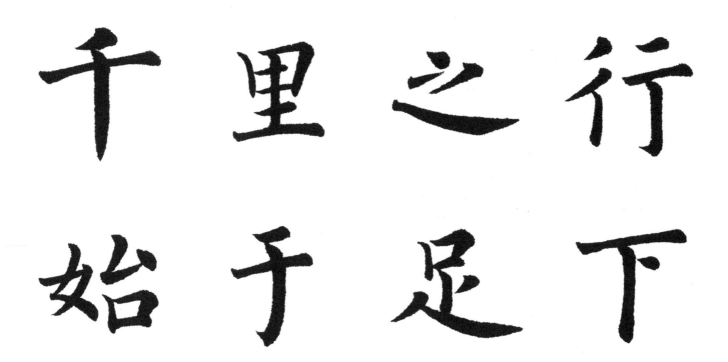

千里之行
始于足下

EVEN A JOURNEY OF A THOUSAND MILES BEGINS
WITH A SINGLE STEP.

TRY ON THIS PAGE

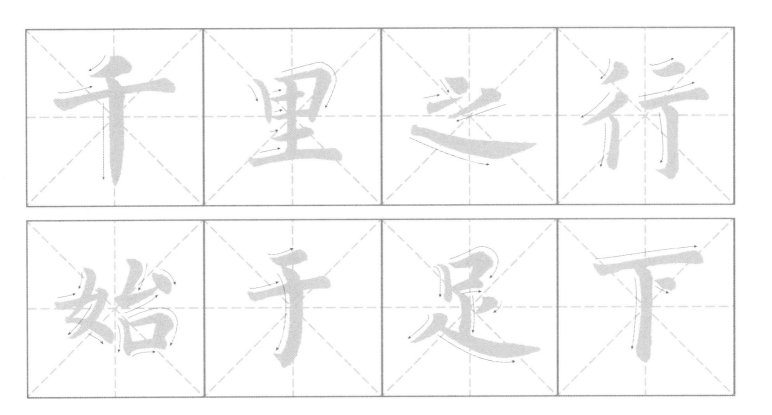

CALLIGRAPHY TOOLS USED:
Ink stick, ink stone, Chinese brush (made from animal's hair)

CREE

WHO & WHERE

The standard story of Cree writing starts with Methodist missionary James Evans in the 1830s. Having previously attempted to adapt the Latin alphabet for the Ojibwe language, Evans turned his attention to Cree, an Algonquian language spoken over wide swaths of Canada, during one long winter at a remote fort in Manitoba. Evans was likely inspired by Sequoyah's Cherokee syllabary, as well as a recently published English shorthand system, and Devanagari, which he had studied. It's also fair to assume he had help from an uncredited Cree assistant or two.

In 1841, Evans introduced his tidy writing system, and it spread rapidly from fort to fort across Cree territory, carried and taught by the hunter-gatherer groups themselves. Within a decade, literacy rates were virtually total, and not long after, the system was adapted for use by various other First Nations languages, from western Athabaskan languages such as Chipewyan to Inuktitut in the east. This called for inventing new symbols for unique sounds, but Evans's principles remained. Together, all these systems are referred to as Canadian Aboriginal Syllabics (or simply syllabics, regardless of which language they're for), and are used across Canada by approximately 200,000 people.

In the mid-20th century, Canadian 'integration' policies, including English-only schooling, disrupted the use of syllabics, and more than a generation went without learning it. The pendulum has since swung back, but in the meantime the Athabaskan versions died out completely. For Inuktitut, by contrast, syllabics use has outpaced even the original Cree. In the Arctic territory of Nunavut, they are an official script, alongside Latin letters, and part of the elementary school curriculum through third grade.

Even where the indigenous languages are more commonly spelled with Latin letters, syllabics have strong symbolic resonance and are often used in artwork, tattoos and other public demonstrations of First Nations culture. The Cree artist Joi T. Arcand, for example, alters photos of street scenes so that all signage – on everything from car dealerships to restaurants to speed-limit signs – is in syllabics. She calls the series *Here on Future Earth*, as if it is a kind of parallel universe that began to unfold at least 180 years ago, during one long winter in Manitoba.

HOW TO USE IT

Evans's system of syllabics for Plains Cree (shown here) and later variations all operate on the same elegant premise. Simple shapes represent consonants with an affixed vowel; rotating the shape changes the vowel. This reliance on position alone makes it unique among alphasyllabaries, as all other systems change the vowel by changing the consonant's shape or adding a diacritic. A consonant without a following vowel has a smaller 'final' form, set above the baseline. Long vowels are indicated with a dot above.

Another feature of Evans's system – perhaps an accident, but a fortunate one – is that it is well suited to both printing and handwriting. Evans first designed it for printing, building his own font set using scrap metal from tea chests and making paper from birch bark. His first printed materials were the syllabary itself and a hymnbook. But the system spread in part because the shapes were also easy to write with far simpler materials. Evans became known as 'the man who taught birch bark how to talk', and a famous, if likely apocryphal, illustration shows him teaching his system with the symbols daubed on a tree trunk with a charred stick.

Syllabics are written left to right, with spaces between words.

PROVERB

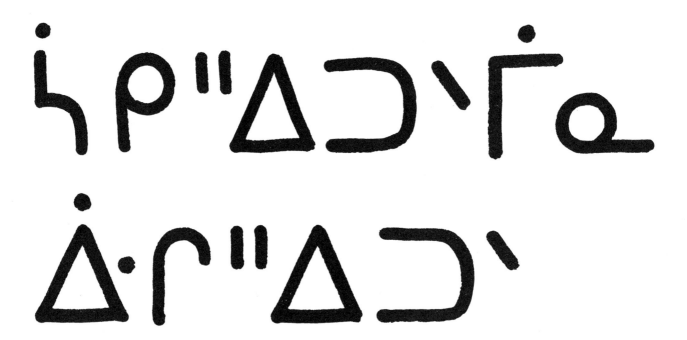

LOVE ONE ANOTHER AND HELP ONE ANOTHER.

TRY ON THIS PAGE

CALLIGRAPHY TOOLS USED:
Sumi and Speedball B-1 nib

CYRILLIC

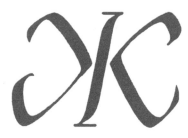

WHO & WHERE

The name 'Cyrillic' comes from the Orthodox St Cyril, a Byzantine scholar and missionary. Born in Thessaloníki in the early 9th century, Cyril is commonly credited with inventing the Cyrillic alphabet – but in truth the letters that more than 250 million people use to write Russian and many other Slavic languages (and quite a few non-Slavic ones as well) were developed by his students. Cyril himself, along with his brother Methodius, appears to be responsible for an earlier alphabet, the first used to write a Slavic language.

In 862 Cyril and Methodius were invited to translate the Bible for the Prince of Moravia (what is now Serbia, Hungary, Poland, Slovakia and the Czech Republic). For the task, they devised a new alphabet tailored to Slavic sounds. The result – what's now called Old Church Slavonic language and Glagolitic script – did not last long in Moravia, as the Catholic pope banned the brothers' work barely twenty years later. But two of Cyril and Methodius' students took the texts to Bulgaria, where they devised a new alphabet that was faster and simpler to write: Cyrillic. The new script was taught in the Bulgarian Empire's literary schools, then spread to Russia in 988, via the Orthodox Church.

Cyrillic use expanded yet further in the Soviet era, when republics from the Arctic through Central Asia adopted it. Since the union's dissolution some states have switched to the Latin alphabet. Moldova, for example, used Cyrillic before 1918 and during the Soviet period, but abandoned it in 1989; the unrecognised republic of Transnistria, within Moldova, maintains Cyrillic. Uzbekistan officially adopted the Latin alphabet in the 1990s, but Cyrillic is still common there. Kazakhstan expects to transition to Latin letters by 2025.

In some Slavic countries early church history dictated choices around script use: western Slavic lands such as Poland became Catholic and adopted Latin letters, whereas eastern, typically Orthodox countries use Cyrillic. These distinctions are upended in the Balkans, with its complex layers of national, religious and ethnic identity. When Yugoslavia was formed in 1918, its official language of Serbo-Croatian was officially written in both Cyrillic and Latin letters: Cyrillic in what is now Serbia, and Latin in what is now Croatia. Arguments continue as to whether Serbo-Croatian is one language or two slightly different ones, but most speakers can read both.

Аа Бб Вв Гг Дд Ее Ёё Жж Зз
Ии Йй Кк Лл Мм Нн Оо Пп
Рр Сс Тт Уу Фф Хх Цц Чи
Шш Щщ Ъъ Ыы Ьь Ээ Юю Яя

HOW TO USE IT

Cyrillic is an alphabet, called *azbuka* in Russian and most other Slavic languages, after the first two letters. It has standalone vowels and consonants and is written left to right. Of the many forms of Cyrillic writing, the 33-letter set used for Russian, shown here, is the most widespread, with about 125 million users.

Many Cyrillic letters are based on Greek ones, but early calligraphic conventions – such as the use of broad-tip pens – have made some of them difficult to recognise. A handful of the letters, such as Ж (*zh*), come from St Cyril's Glagolitic. Two others, Ш (*sh*) and Щ (*sht*) may have come via Glagolitic from Aramaic; compare them to the Hebrew *shin*, ש. Cyrillic has also changed over time, dropping a few of the more complex characters, such as the Glagolitic-derived Ѫ (called big *yus* in Russian) and Ѧ (little *yus*). These represented nasal vowels that have fallen out of Slavic languages.

Russian Cyrillic was modernised in 1708 by Tsar Peter the Great, who commissioned new typefaces and personally selected the best letters for a new 'civil script'. Originally Cyrillic was written in all uppercase letters. Today's lowercase set developed in the 14th century as a smaller, rounder version of the block set. It can differ markedly from the printed alphabet.

SLAVIC CYRILLICS

Technically, there is no single Cyrillic alphabet. It's more appropriate to speak of Cyrillics, for all the various languages that use the system. Even within the Slavic language family, there are variations beyond a common set of (usually) 29 letters. Belarusian has three distinctive letters (two shown here, bottom row). Ukrainian adds four (third row). Serbian shows some of the greatest variation, using only 24 of the core Cyrillic letters and adding six others (top two rows), one of which is the Roman J. To complicate matters, a given letter may not represent the same sound qualities from language to language. A Г, for example, is a hard g in Russian but a fricative g (like the Greek gamma, from which the Cyrillic is borrowed) in Belarusian.

Кк Ҭҳ Єє Ҩҩ

Цӷ Ӫӫ Ҕҕ Җҗ

NON-SLAVIC CYRILLICS

Via the Russian Empire and, later, the Soviet Union, Cyrillic has been adapted to write many non-Slavic languages. In far northwestern Russia it is used to write Kildin Sámi, a Uralic language of the Sámi people (indigenous Laplanders). Caucasian languages such as Chechen (in Chechnya, replacing Arabic script), Abkhaz (in Georgia, with 62 letters) and Avar (in Dagestan) use it, as do many Turkic languages in Central Asia. Even a Chinese language, Dungan, spoken in Kyrgyzstan and Kazakhstan, uses Cyrillic. Each language, whether Slavic or non-Slavic, uses a specifically tailored letter set. New letters have been formed with small modifications – such as 'tails' – or invented out of whole cloth, and in some cases digraphs (two-letter combinations) or even trigraphs (three letters) stand in for unique sounds.

PROVERB

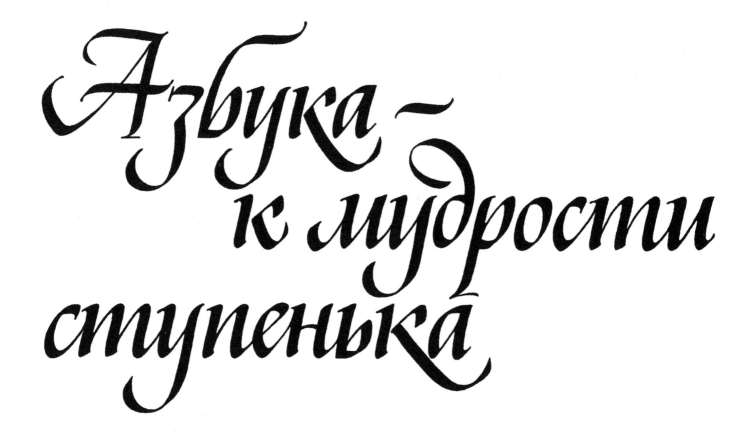

Азбука –
к мудрости
ступенька

THE ALPHABET: THE FIRST STEP TO WISDOM.

TRY ON THIS PAGE

CALLIGRAPHY TOOLS USED:

Parallel pen, ink

DEVANAGARI

WHO & WHERE

The history of Devanagari starts in the 7th century BC, with the ancient Brahmi script, the predecessor of virtually all current writing systems across South Asia; collectively, these scripts are called Indic. The most iconic evidence of Brahmi is from the collection of 3rd-century-BC inscriptions known as the Edicts of Ashoka. These carved pillars, cave walls and stones outlined Emperor Ashoka's principles for living and ruling according to the Buddhist spirit of dharma, including practical measures such as planting banyan trees for shade and digging wells for public watering places.

In subsequent centuries Brahmi split into North Indic and South Indic, then spread and diverged even further. South Indic scripts took on distinctive curves when they were adapted to writing on palm-leaf

paper, which shreds when incised with straight lines. Whether in the Himalayas or the Philippines, however, almost all of the Indic scripts still share a few common points: consonant symbols also have an inherent vowel; consonants can combine into special characters or stacks; and vowels have an independent form and a combining form.

Descended from the northern branch of Brahmi, Devanagari was previously known simply as Nagari – from *nagari lipi*, 'script of the city', with inscriptions found around northwest India starting in the 7th century AD. The 'Deva' (divine) part of the name came around 1000, when the script was adopted and refined for writing holy texts in Sanskrit, the ancient liturgical language of Hinduism, and it spread via these texts far into Southeast Asia. This period

was also when Devanagari developed its characteristic top bar, for joining letters in a word.

In part due to its use in writing religious texts, Devanagari is by far the best known of the Indic scripts. As the fourth-most-used writing system in the world, it's used by at least 600 million people to write more than a hundred languages. The majority are in the Indo-Aryan family, and the foremost is Hindi, which is also the fourth-most-spoken language in the world. (When combined with Urdu, which is very similar but written in Arabic script, Hindi surpasses Spanish to become third most spoken.) In India alone, 10 of the 22 languages listed in the constitution use Devanagari. In Nepal the languages of Boro and Nepal Bhasa, in the Sino-Tibetan family, use the script as well.

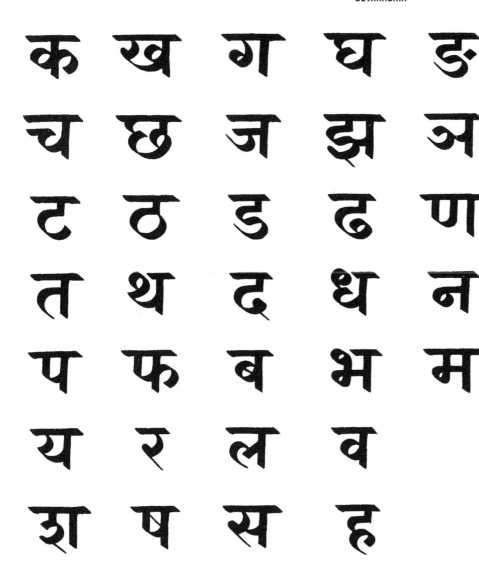

HOW TO USE IT

One of the hallmarks of Brahmi scripts is the order of the consonants: they are consistently grouped according to where in the mouth they are pronounced, beginning in the back of the throat (top row, starting with *ka* and *kha*) and ending on the lips (fifth row, letters like *pa*). Two more rows have less-classifiable sounds like *ra*. Because Devanagari is used for many different languages, the letter set can vary a bit. The most widely used version, for Hindi, has 47 characters – the 33 consonants shown here, and 14 vowels. Together, the letters and their specific order are called the *varnamala*, the 'garland of letters' – or, in more prosaic translation, the alphabet.

Devanagari is not technically an alphabet, however, but an alphasyllabary or abugida, as are all Indic and Brahmi scripts. In Devanagari the inherent vowel is *a*, so the first consonant, क, represents not *k* but *ka*. Independent vowel symbols do exist, but they are used primarily at the beginning of words; within words, any different vowel from the default *a* is indicated with a small mark above, below or alongside the consonant.

Letters are written from left to right, and written in cursive. Words are connected via the distinctive top line, which is called a *matra*.

SAMYOGA

The word *samyoga* means 'yoked together' in Sanskrit and refers to the convention of combining two or more consonants in a single symbol, a very common practice in Devanagari and most other Indic scripts. This is done when consonants are clustered, that is, pronounced without intervening vowels. Sometimes the combinations are straightforward, and the two original letter shapes are obvious in the new one. More often the letters are creatively modified to fit two or three in the space of one, so that at first it is difficult to discern the original letter shapes. Some odd combinations must simply be memorised, but for others, general principles apply, such as dropping redundant vertical lines (as in the top row) or stacking two letters (second and fourth rows). Once these patterns are learned, the conjuncts are easier to guess.

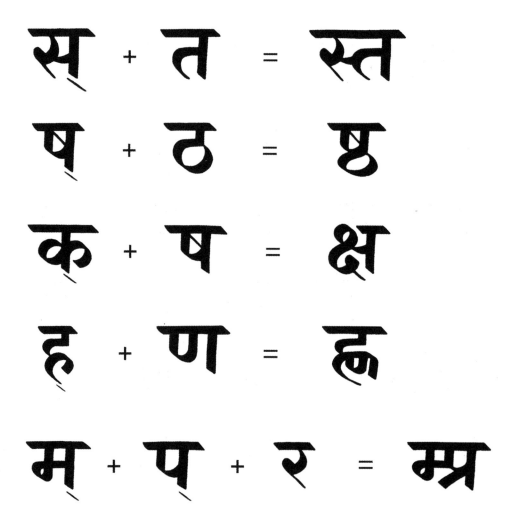

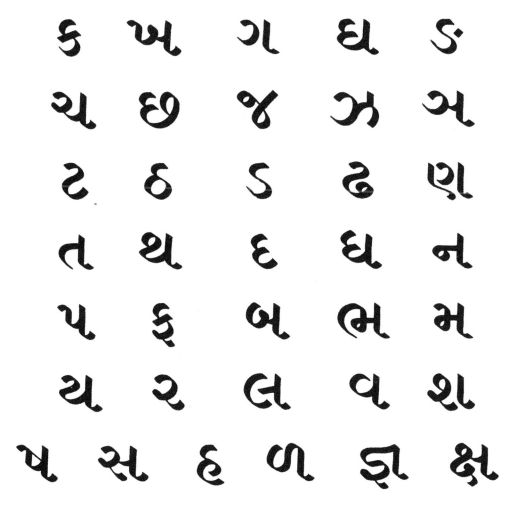

GUJARATI

A distinguishing characteristic of most North Indic scripts is the use of a headline to connect the letters – but Gujarati is an exception. Used by 48 million people for the Gujarati and Kutchi languages spoken in northwest India, the script, when compared letter for letter, is similar to Devanagari – just without the *matra*. It developed into its own system after the 10th century; in the 17th century, it lost its headline, for faster cursive writing in bookkeeping and letters. This adaptation earned it the nickname *saraphi* (bankers' script) or *mahajani* (traders). True to these roots, some boosters of Gujarati still cite its cost-effectiveness: that missing *matra* conserves both ink and effort. Mohandas K. Gandhi, born in Gujarat, helped promote Gujarati as a broader literary language and served for a time as head of the Gujarati Literary Council.

PROVERB

घर की मुर्गी दाल बराबर

CHICKEN EATEN AT HOME TASTES LIKE DAAL.

TRY ON THIS PAGE

CALLIGRAPHY TOOLS USED:
Reed pen tip cut in 40° right canted angle

GE'EZ

WHO & WHERE

Ge'ez script, also known as Ethiopic, is used by more than 60 million people for various languages in Ethiopia, Eritrea, Somalia and parts of Sudan. Most of these languages – such as Amharic, Tigrinya and Tigre – are in the Semitic family, and in their grammar and vocabulary they bear a clear resemblance to other Semitic languages such as Arabic and Hebrew.

Far less obvious is how Ethiopic writing is related to scripts of the Middle East. For a time, linguists thought the Ethiopic *fidäl* (script) was a later invention, as it does not at all resemble Arabic or Hebrew systems, nor does it even function the same way. Arabic and Hebrew have letters for consonants only, but Ethiopic's letter set is syllabic, with symbols representing consonant-vowel combinations.

The key link is a sister system to Phoenician: an abjad called Ancient South Arabian, which dates back to the 9th century BC. Cave inscriptions found in Eritrea and Ethiopia confirm that Ancient South Arabian script, which bears some resemblance to contemporary Ethiopic, was present on both sides of the Red Sea at least by the 7th century BC. In the 1st century BC, Old Ge'ez shows the letters taking on their current shape.

Ethiopic shifted to a syllabic system by the mid-4th century AD, but possibly earlier. Traditional credit for the innovation goes to St Frumentius, first bishop of the Ethiopian Orthodox Church. A Syrian Christian, Frumentius tutored and later converted King Ezana of Aksum, the powerful kingdom that controlled parts of what's now Ethiopia,

Eritrea, Sudan and Yemen. The more precise writing system was rapidly taken up by the church, as it helped in translating and writing the Bible clearly.

Ge'ez is also the name of the liturgical language of the Orthodox churches of Ethiopia and Eritrea, as well as of Beta Israel, the Ethiopian Jewish community. Ethiopic script, even when used in a secular context, still has some religious associations, and is also connected with the dominant Amharic-speaking culture of Ethiopia (where Amharic is the official language). To differentiate themselves, some minority language and ethnic communities in the Horn of Africa have moved away from Ethiopic letters. Most notably, Oromo, spoken by 34 million people in Ethiopia, Kenya and Somalia, switched from Ethiopic to Latin letters in 1991.

HOW TO USE IT

Ancient predecessors of Ethiopic were commonly written boustrophedon, back and forth, and Ge'ez eventually settled on left to right, in contrast to scripts for other Semitic languages. And while other Semitic-language scripts favour consonants, Ge'ez has a specific character for every possible consonant-vowel combination. The letter set for Amharic, for instance, is laid out in an orderly 34-by-7 table (shown here in three sections).

Each consonant has an inherent schwa vowel, which can tend more toward *a* or toward *e*. Extra flags, hooks or curls are added to indicate other vowels. In the second column of the table, the vowel *u*, for example, is almost always indicated with a small flag midway up the right side of the letter. The system is so consistent that the linguistic term abugida, for an alphasyllabary, is drawn from four Ethiopian consonants, just as the term abjad comes from Arabic consonants. Users of the script refer to their letter set as *halehame*, for the first four consonants in the syllabary table.

The characteristic thick strokes and angles of Ethiopic letters were established by calligraphers working with a flat-tipped reed pen on parchment. While many other calligraphy traditions shifted to paper when it became available, a few monasteries in Ethiopia maintain the laborious tradition of making and writing on parchment, just as it was done in the 4th century AD.

PROVERB

ቀስበቀስ እንቊላል

በእግራ ደሄዳል

LITTLE BY LITTLE, EVEN AN EGG WILL WALK.

TRY ON THIS PAGE

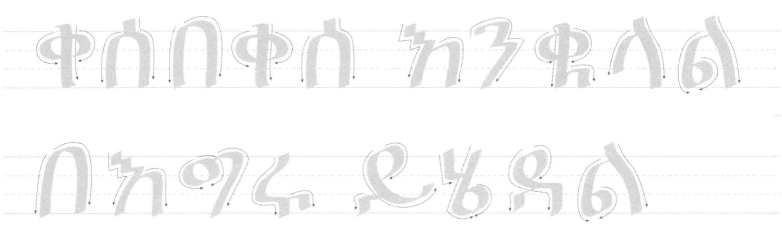

CALLIGRAPHY TOOLS USED:
Black non-waterproof ink and Pilot Parallel Pen 3.8mm

GEORGIAN

WHO & WHERE

Considering its relatively small user base of 4.5 million people, the Georgian alphabet might seem at risk. The writing system is even listed as part of UNESCO's Intangible Cultural Heritage programme, which provides funds for educators and calligraphers in the tiny Caucasus nation. But Georgians have a deep pride in their script that ensures its daily use (in fact, there are three scripts, but one is in the most common use). As in neighbouring Armenia, where a distinct alphabet has helped preserve culture, Georgian identity has stayed strong even under pressure from Persia and Byzantium in ancient days and, more recently, the Soviet Union.

In the Soviet period, Armenia, Azerbaijan and Georgia, unlike the other republics in the union, officially maintained their own languages. In 1978, however, Soviet politicians proposed altering the constitutions in the three distinct republics, to add Russian as a co-official language. This provoked outrage in Georgia, and more than 20,000 people took to the streets in support of their language. Eduard Shevardnadze, the Georgian secretary of the Communist Party, intervened, and the Kremlin soon withdrew the proposal in Georgia, as well as in Armenia and Azerbaijan. The day of the protests, 14 April, is still marked as Georgian Language Day.

Some sources credit Mesrop Mashtots, inventor of the Armenian script, with devising the Georgian script as well. But Georgian sources point instead to King Pharnavaz I, who reigned in the 3rd century BC. The oldest evidence of Georgian writing so far found is not this old, though, and is not in Georgia itself, but in the Holy Land. Georgian pilgrims left graffiti in Nazareth possibly as early as 340 AD, and Georgian letters adorn a mosaic floor at St Theodore Georgian monastery, outside of Jerusalem, dating from 430 AD.

The Georgian language is indisputably unique, however, and stands nearly alone in its Kartvelian language family in the Caucasus (Georgians call themselves 'Kartvelebi', supposedly after Kartlos, great-grandson of Japheth in the Bible). Related languages Svan and Mingrelian – spoken in different parts of Georgia – also use the Georgian alphabet, whereas outlier language Laz is now used mostly in Turkey and has adopted the Latin alphabet. Georgian itself is spoken in some parts of Turkey, Iran and Azerbaijan. The Kartvelian languages share some grammatical oddities with Basque; linguists are still developing hypotheses to explain the connection.

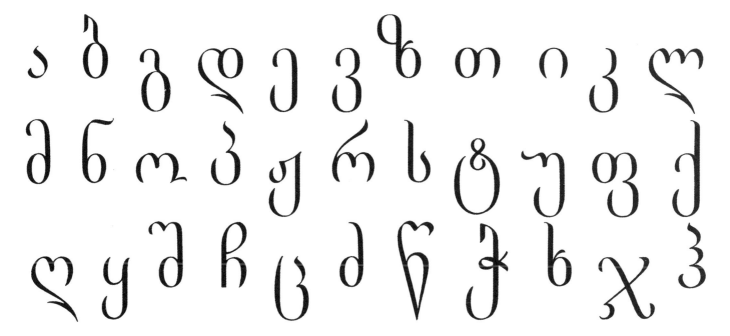

HOW TO USE IT

Georgian is a true alphabet, with stand-alone consonants and vowels – 33, as of its codification in 1879. The letters have gone through several phases; it could be called three scripts in one. The modern version, *mkhedruli* ('warrior' script) first appeared in the 10th century. The oldest form, *asomtavruli* (also called *mrgvlovani*, 'rounded'), a set of perfect arcs linked with right angles, is seen in church inscriptions. Medieval religious manuscripts used right-slanted *nuskhuri* letters, offset with

beautiful illuminated *asomtavruli* capitals.

Georgians are introduced to all three scripts in school, but typically can read only *mkhedruli*. The older scripts are used in monasteries and other religious contexts. In the 1950s, linguist and Tbilisi State University founder Akaki Shanidze tried to revive *asomtavruli* for proper nouns – echoing the use of those medieval illuminated capitals – but the practice never truly caught on. The 33-letter *mkhedruli* alphabet, shown above, does not have

a separate uppercase set, but capitals are made by scaling letters up so they fit between a baseline and headline. Good handwriting gives an even proportion to ascenders and descenders.

Since 1880 all Georgian students have learned their language from a textbook called *Deda Ena* (Mother Tongue), the work of educator Iakob Gogebashvili. The book begins with the *mkhedruli* alphabet and proceeds through simple folk tales and excerpts from national literature.

PROVERB

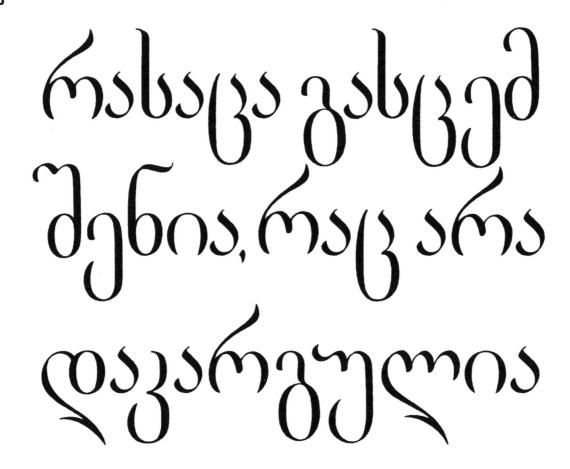

 რასაცა გასცემ შენია, რაც არა დაკარგულია

WHAT WE GIVE MAKES US RICHER; WHAT WE HOARD IS LOST.

TRY ON THIS PAGE

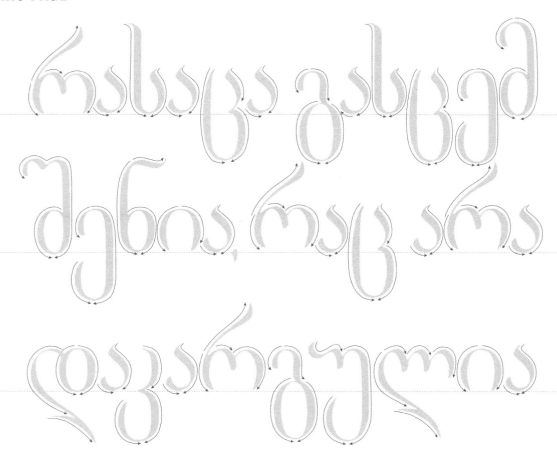

CALLIGRAPHY TOOLS USED:
Automatic pen, Chinese ink

GREEK

WHO & WHERE

Greek speakers may number only about 13 million today, and the language and its accompanying script are official in just two countries (Greece and Cyprus), but these statistics belie the deep and global influence of the Greek alphabet.

That influence comes in part because Greek has been around so long. While other writing systems have older ancestors, Greek letters have been used, almost unchanged, since at least 750 BC. In that time the alphabet spread, especially via Alexander the Great, through the Caucasus, Central Asia and into India; an inscription in Kandahār dated 260 BC is written in Greek and Aramaic. In later centuries Greek at least partially influenced Armenian and Georgian writing.

Reaching south and west, the Greek alphabet inspired Coptic writing in Egypt, and both the Roman (Latin) alphabet and Cyrillic. Gothic script, invented in the 4th century AD to write that now-extinct Germanic language, also borrowed Greek letters. At the start of the European Union, Greek was the only official language with a non-Latin alphabet, so the new banknotes were labelled 'ΕΥΡΩ' as well as 'EURO' (Cyrillic 'EBPO' was added in 2007 when Bulgaria was admitted to the union). Worldwide the Greek alphabet is used to write the 'languages' of science, engineering and complex mathematics.

Ancient Greeks developed several earlier writing systems, including the syllabic script scholars have dubbed Linear B – the oldest known form of Greek, at 3400 years old. All were replaced when, according to Herodotus, Phoenicians brought their alphabet to Cadmus, King of Thebes. But where Phoenician had only consonants, Greek added stand-alone vowel symbols. This innovation almost certainly made the script more easily adaptable to other languages, and the idea is now so ingrained that the majority of the world's writers simply take it for granted. In technical linguistic terms, an alphabet is any writing system that follows the Greek model, with independent consonants and vowels.

The word 'alphabet' comes from Greek too, but its roots are in Phoenician, which named its letters with words that begin with the relevant sounds: Phoenician *aleph*, meaning ox, became Greek alpha; *bet*, house, became beta. Many other languages have adopted this same pattern, naming their own scripts after their first letters.

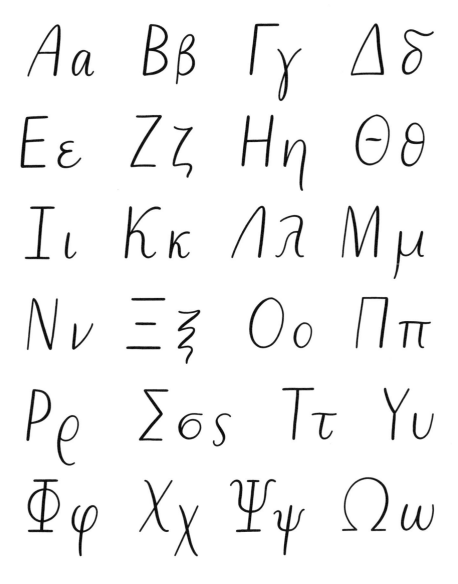

HOW TO USE IT

Ancient Greek inscriptions run in every possible direction, including boustrophedon, named for an ox tilling a field: back-and-forth lines that made inscriptions on wide slabs of stone easier to read. They eventually settled into left-to-right horizontal lines by about 500 BC. A century later, in 403 BC, the city of Athens adopted the alphabet still used today: 24 letters, from alpha to omega ('big o', distinct from omicron, 'little o'). Greek lowercase letters developed later, probably inspired by a similar practice in the Roman alphabet, and were not formalised until the 9th century.

One element of Greek writing that remained in flux until very recently was its accent marks. Classical Greek used a number of marks to show pitch. An inverted comma above a vowel, for instance, indicated 'rough breathing', a preceding h sound (which gave English some Greek-root words like hero and hymn). The notation faded, but when the modern nation of Greece was established in the early 19th century, its founders wanted to conjure ancient glory and so reinstated three marks and many archaic grammar rules, in an arcane written language called Katharevousa (purified), which no one actually spoke. Katharevousa was finally ousted, along with the military junta, in 1974. Now only a single accent is used, to mark the stressed syllable.

PROVERB

Το κρασί και τα παιδιά λένε την αλήθεια

WINE AND CHILDREN SPEAK THE TRUTH.

TRY ON THIS PAGE

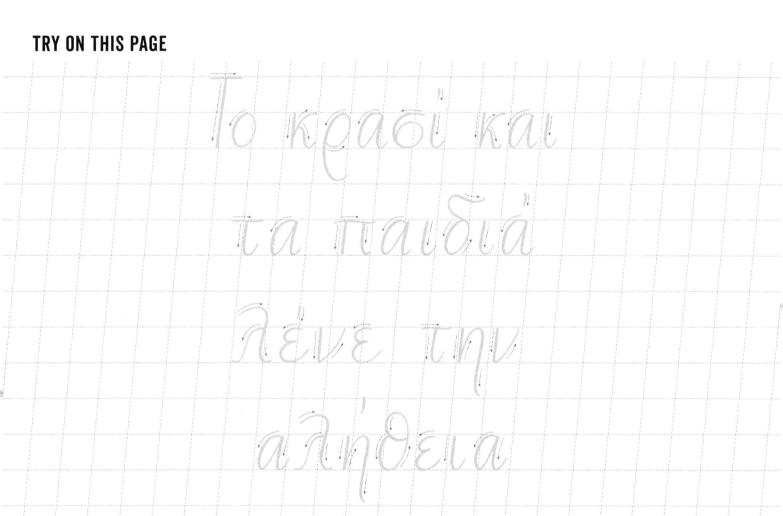

CALLIGRAPHY TOOLS USED:
Fine felt-tip pen, or fine brush lettering pen

HANGUL

WHO & WHERE

Hangul script, used to write the Korean language, had an exceptionally long path to acceptance. King Sejong the Great invented it in 1443, when he wasn't busy with other major projects such as establishing Confucianism in Korea and advancing agricultural science. At the time, the Korean language – an isolate, unrelated to its neighbours – was written in Chinese characters, a system too complex for all but the most highly educated. Sejong's simpler, phonetic Hangul was a form of writing that was accessible to the masses. But this threatened the scribal elite and later rulers, who for centuries blocked Hangul from official use. In 1894 Hangul was finally used in some state documents; after World War II, it became Korea's official script.

Hangul is admired for its elegant internal logic and consistency, as well as its phonetic accuracy – all of which make it exceptionally easy to learn. South Korea has a literacy rate of 98 percent, and children often learn to read at home, before they attend kinder-garten. Some 80 million people on the Korean peninsula and in parts of Russia and China use the script daily. Hangul's ease of use has even attracted speakers of Cia-Cia, an Austronesian language spoken by 80,000 people on the island of Buton in Indonesia. School leaders there have campaigned to make it the official script, replacing Latin letters.

Stuck between China and Japan – and occupied by the latter from 1910 until the end of World War II – Korea has worked hard to carve out space for its distinct culture, language and literature. Through South Korea's rapid globalisation, the world has come to know K-pop boy bands and Korean soaps; now the country's literati are focussed on promoting higher culture as well. Since 1996, the government-funded Literature Translation Institute of Korea has been translating the country's classic canon of poets as well as con-temporary novelists, and marketing their work around the world. Han Kang's novella *The Vegetarian*, supported by LTI Korea, won the prestigious Man Booker International Prize in 2016. The end goal: a Nobel Prize in Literature, which no Korean has won yet.

ㄱ ㄲ ㄴ ㄷ ㄸ ㄹ ㅁ ㅂ ㅃ ㅅ ㅆ

ㅇ ㅈ ㅉ ㅊ ㅋ ㅌ ㅍ ㅎ

ㅏ ㅐ ㅑ ㅒ ㅓ ㅔ ㅕ ㅖ ㅗ ㅘ ㅙ ㅚ

ㅛ ㅜ ㅝ ㅞ ㅟ ㅠ ㅡ ㅢ ㅣ

HOW TO USE IT

Hangul is difficult to classify. It has stand-alone vowels, which makes it an alphabet. A syllabary logic drives the writing, though: letters are stacked and clustered in blocks, each representing a syllable. The clusters are written and read left to right, with the letters in each syllable arranged from top left to bottom right.

There is a similarity to Chinese characters, and not just because brush-written Hangul has some of the same strokes. In fact, the Hangul letters, like Chinese logograms, draw pictures. In a simple way, the shape of each of the 14 consonants (the top two rows here, which includes double letters) corresponds to the shape of the mouth as the sound is pronounced. In the first letter, *giyeok*, for example, the top horizontal line represents the roof of the mouth, and the short vertical one is the back of the tongue, which raises to pronounce the hard *g* sound.

The vowels (the bottom two rows) are also an elegant system, with just three elements: a vertical line (said to represent a person); a horizontal line (earth); and a point (the sun), now a short bar. The shapes follow a pattern – vertical letters represent high vowels, for example – so that what was 10 basic vowels has expanded to a set of 21 symbols, to represent full pronunciation.

65

PROVERB

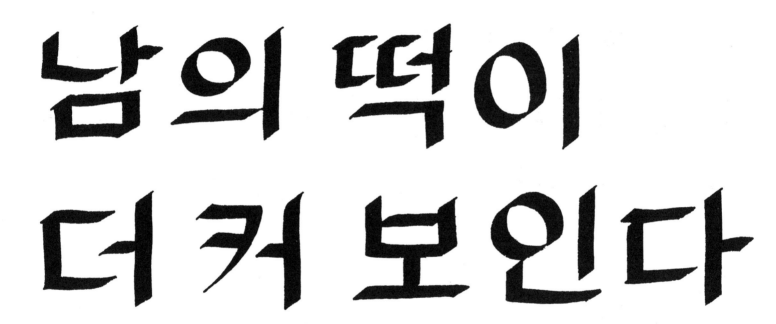

남의 떡이 더 커 보인다

OTHER PEOPLE'S RICE CAKES ALWAYS LOOK BIGGER.

TRY ON THIS PAGE

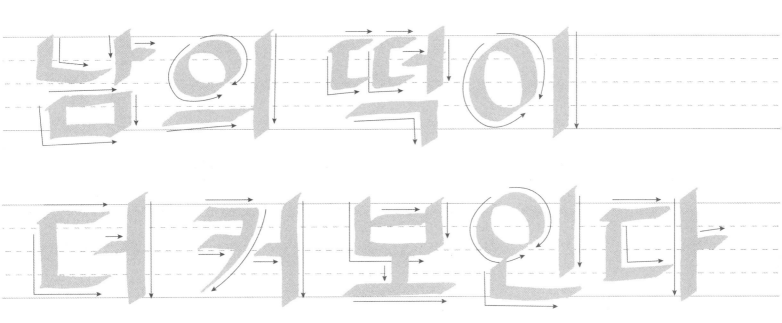

CALLIGRAPHY TOOLS USED:
Black non-waterproof ink and 3.8mm calligraphy pen on drawing paper

HANUNÓ'O

WHO & WHERE

The Hanunó'o script is used by only approximately 20,000 people, on the southern half of the island of Mindoro, but it carries the weight of a whole pre-colonial writing tradition in the Philippines. Before the arrival of Portuguese explorer Ferdinand Magellan in 1521, and subsequent colonisation by the Spanish, this angular writing was just one of many scripts, collectively called *suyat*, used across the islands. Most of the *suyat* are derived from Brahmic, via the Kawi writing system used in parts of Indonesia; a form of Arabic script has also been used in the southern, majority-Muslim islands. The oldest surviving trace of *suyat* writing is from the 10th century, in a now-extinct Malay language. Ultimately, though, Spanish rule dictated the use of Latin script, which all but extinguished the islands' calligraphic diversity.

The Hanunó'o script is one of the few *suyat* to survive, because the Hanunó'o tribe – a subgroup of Mindoro's Mangyan people – has lived in relative isolation, practising subsistence farming, weaving indigo-dyed clothing and maintaining their animist beliefs. They have traditionally used their writing system to record *ambahan*, a form of poetry distinguished by seven syllables in each line, with rhyming end syllables. The poems comment on love, family relationships and nature, and are typically written then chanted aloud.

More than most countries, the Philippines has made efforts to reclaim and preserve its indigenous scripts. Language activists succeeded in having the four living *suyat* scripts – Hanunó'o; the fellow Mangyan script of Buhid, used in north Mindoro; and Tagbanwa and Pala'wan, used in Palawan province – declared National Cultural Treasures in 1997, and added to the UNESCO Memory of the World Programme in 2009. Legislators have also twice proposed the National Script Act, which proposes to revive all known *suyat* scripts. Although Hanunó'o is probably the most regularly used of the *suyat* systems, Baybayin, the currently disused script formerly used to write Tagalog, may in the end see a more widespread revival, as its curving forms are associated with broader Filipino culture and heritage, and now appear on banknotes and in tattoos.

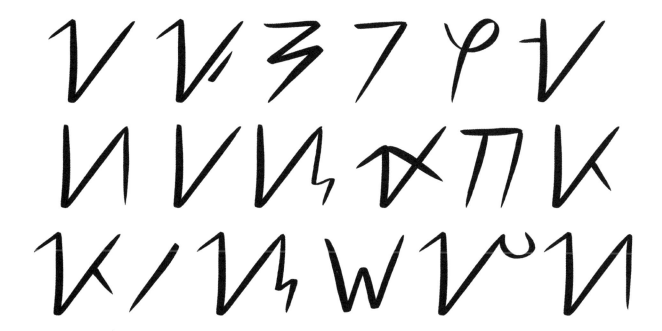

HOW TO USE IT

Hanunó'o is traditionally incised with a knife into long pieces of bamboo, and this medium dictates both the angular, slightly jagged shape of the letters and the unique way in which it is written: in vertical lines running upward, away from the body. For reading, the bamboo piece is then rotated so the lines run horizontally, with letters running left to right. The letters themselves can be written horizontally or vertically, or even, to accommodate left-handed writers, in mirror image.

Hanunó'o is an alphasyllabary, but it is far more concise than its Indic ancestors, reflecting the language's smaller number of phonemes. (Hanunó'o is an Austronesian language, related to Malaysian, Javanese and of course most of the 120-plus other languages in the Philippines archipelago.) There are only 18 characters: three stand-alone vowels (the first symbols on the left in the top row), plus 15 consonants, each with the inherent vowel a. Other vowels are marked with diacritics placed above or below the central symbol, or, if the letters are rotated, to the left or the right of the symbol.

Hanunó'o script has been preserved through traditional use of *ambahan* poetry, which teenagers typically learn as part of courting rituals. But the bamboo medium is also highly perishable, so otherwise there is little physical written record of Hanunó'o history.

PROVERB

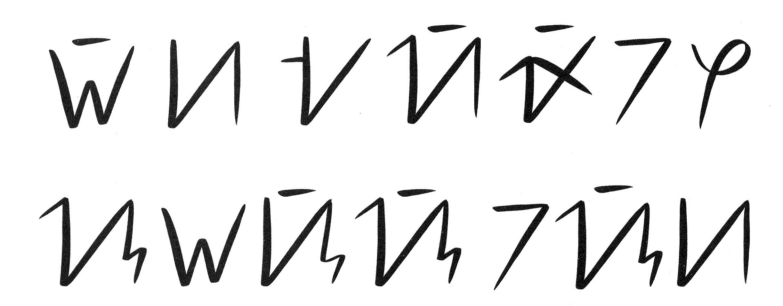

**DOESN'T MAN ALWAYS GO BACK
TO HIS DWELLING PLACE, HIS HOME?**

TRY ON THIS PAGE

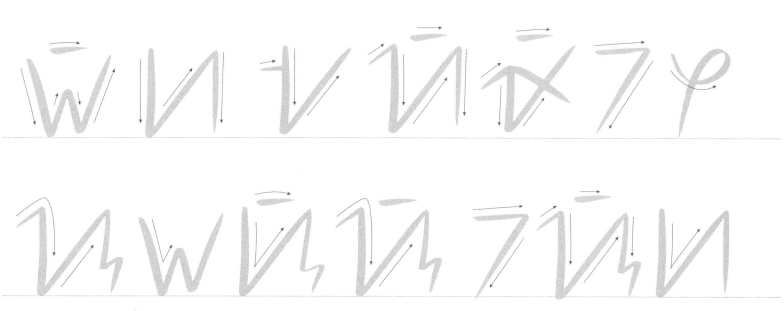

CALLIGRAPHY TOOLS USED:
Bamboo reeds or copic markers

HEBREW

WHO & WHERE

Hebrew is simultaneously one of the world's oldest languages and one of its newest, as well as one with both a small number of speakers (9 million, mostly in Israel) and a substantially larger number of readers (14 million or more, around the world). Hebrew script is far-flung too: it has been used to write Yiddish in Europe; Ladino around the Mediterranean; and even Karaim, a Turkic language spoken by Crimean Jews.

Hebrew has lived through two alphabets. The first, probably based on Phoenician (and looking a great deal like Tifinagh), dates to the 10th century BC, but by about 1200 BC it was replaced with letters derived from Aramaic. A millennium later, as seen in the Dead Sea Scrolls, these letters were fairly standardised and had taken on their distinct square shape that's still recognisable today.

As Jewish people migrated around the Middle East and into Europe and joined other communities, spoken Hebrew fell out of use. From the 5th century AD or so, the language existed almost entirely in religious texts and commentaries, with occasional philosophy and poetry.

On 13 October 1881, in Paris, a French newspaperman named Eliezer Ben-Yehuda spoke Hebrew aloud for the first time in centuries – or that's how the legend goes. Less romantically, as historian Cecil Roth put it, 'Before Ben-Yehuda, Jews could speak Hebrew; after him, they did.' At the same time, written Hebrew was undergoing a kind of creative renaissance, dubbed the Haskalah (Enlightenment), in which writers were modernising the language and extending its use beyond the religious sphere.

These efforts came together to provide Zionists in Palestine a common language, one that dispensed with the archaic grammar of Biblical Hebrew. Thanks to Ben-Yehuda's coinages, it had words for new technologies, concepts and even vegetables such as tomatoes and eggplants, which had come to the Mediterranean after spoken Hebrew had gone into hibernation.

Hebrew writing has since flourished. SY Agnon won the Nobel Prize for Literature in 1966, and in 1986, Anton Shammas wrote the novel *Arabesques*, the first work in Hebrew by a non-Jewish Israeli. Contemporary writers are honoured at Hebrew Book Week, a national festival across Israel, and by the national Sapir Prize for literature.

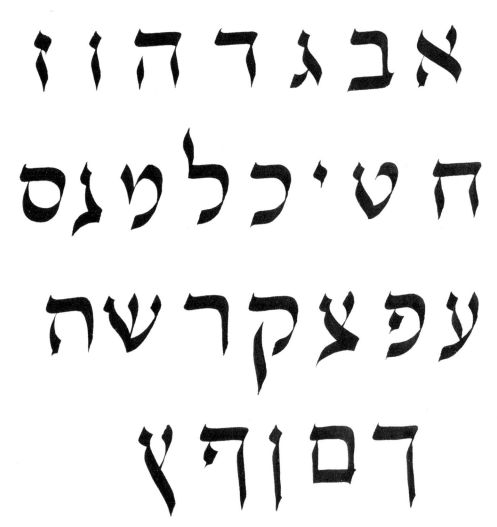

HOW TO USE IT

The Hebrew *aleph-bet* is an abjad with 22 letters, written right to left. Five consonants have an additional form (the bottom row here) for use at the end of words, and four long vowels, similar to the Arabic system, can also function as consonants. *Nekkudot*, clusters of dots and short lines above or below the letters, indicate short vowels, but just as in the Arabic abjad, these vowel marks are considered optional.

Nekkudot also distinguish a few consonants. The three-pronged symbol on row 3 is both *sin* and *shin*. In formal or biblical contexts, a dot is set above the left prong (for the s) or the right (sh). But as with vowel marks, more often the dot is not used. Modern pronunciation has made some letters redundant – *aleph* and *ayin*, for instance, sound the same, as do *kef* and *qof*.

Hebrew's distinctive block letters (*merubba'* or squared, shown here) have been rendered over the centuries with both quill pens among Ashkenazi Jews and reed pens in Sephardic tradition. They are aligned not on a baseline, but all hanging from an invisible top line. The most common handwriting is cursive *rahut* (flowing). Rashi script, named for a medieval French author, falls somewhere in between – it has the clarity of block letters, but some of the fluid quality of cursive.

PROVERB

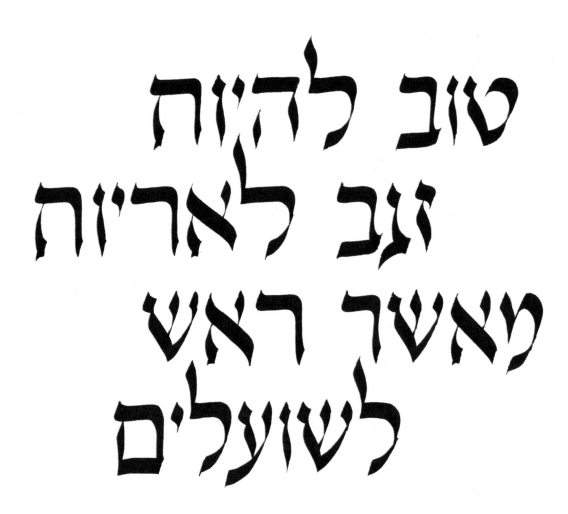

טוב להיות
זנב לאריות
מאשר ראש
לשועלים

BETTER TO BE A TAIL TO THE LIONS THAN THE HEAD OF THE FOXES.

TRY ON THIS PAGE

CALLIGRAPHY TOOLS USED:
Speedball Left hand nib, size C0

JAPANESE

WHO & WHERE

Japanese ranks among the world's most difficult languages for non-native speakers to learn. It is a relative anomaly, not definitively related to any other language (though some linguists have proposed a connection to Korean and even Turkish), so learners have little frame of reference for its grammar and vocabulary. The other major challenge is its complex and deeply nuanced writing system – or rather, *systems*. Any given text can be composed of both logographic and phonetic symbols: primarily, a set of about 2000 adapted Chinese characters, called kanji, as well as the two phonetic syllabaries hiragana and katakana, known as kana for short. And that's not even counting romaji (Latin letters) and emoji, which have been in use since the 1990s.

Apart from the worldwide embrace of emoji, Japanese writing is limited to the nation of Japan and the 126 million people who live there – plus another million or so worldwide who have managed to learn it as a second language. Before Chinese characters were introduced in the 6th century AD, the Japanese language had no (known) native writing system. The characters – and, at first, the Chinese language – became the standard for bureaucracy and business, and for any service to the imperial court. By about 650, scribes had developed a system that used Chinese characters to represent Japanese sounds, rather than meaning; this eventually became the phonetic kana sets in use today.

Aggressive reforms and standardisation started around 1900, when lists of kanji were first codified. The most recent list, approved by the ministry of education in 2010, consists of 2136 characters, half to be learned in primary school and half in secondary school. Occasionally reformers advocate for abolishing kanji entirely, as the phonetic kana can in theory express the whole language. Some have even pressed for going full Romaji, arguing that Japanese writing keeps the country too isolated from the West.

But even if it strikes some people as unwieldy, the combined kanji-kana system is likely here to stay. Kanji help clarify the language's many homophones. And since early technical limitations have been overcome, Japanese writers and texters can now communicate with ease on all their digital devices, employing the full range of kanji and kana that make Japanese writing so unique and nuanced.

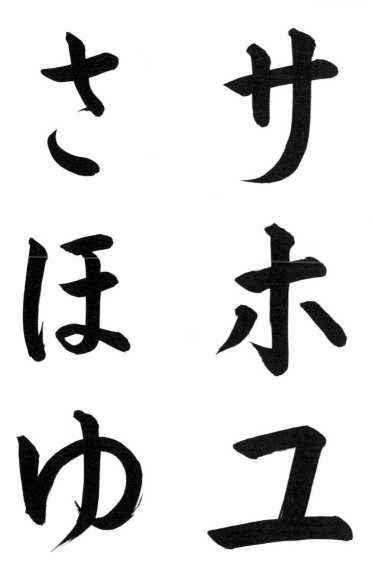

HOW TO USE IT

Traditionally both kanji and kana were written as Chinese is: in vertical columns, from right to left. Now horizontal writing, read left to right, is common too. On a page of manga, however, the action usually flows across the panels from right to left. So Japanese books can be printed either with the spine to the right or to the left, depending on the content.

Japanese calligraphy (shodō) is a revered art and ritual, a Buddhist mindfulness practice and one of the traditional Japanese 'ways', along with judo (the 'soft way' martial art), sadō (tea ceremony) and others. The tools of calligraphy are referred to as the 'four friends' or the 'four treasures': paper made from mulberry bark (washi), a solid block of black ink, an inkstone for blending ink with water, and a brush. Brushes were for centuries the specialty of a single town, Kumano. They can be made of anything from mountain-goat hair to feathers to obtain varied effects. Initially artists imitated traditions established in China, but the monk Kūkai pushed for a distinct Japanese calligraphy style in the late 8th and early 9th centuries. Kūkai is also credited with inventing kana and penning the iroha, a seven-line poem about the fleeting nature of life that forms a pangram, using each of the hiragana characters once.

The two sets of kana in Modern Japanese, hiragana and katakana, each have 46 symbols and represent the same sounds, but they are employed in subtly different and creative ways, according to content and context. For students, standard writing – kanji and kana together – may be followed by a transliteration in pure hiragana showing the pronunciation.

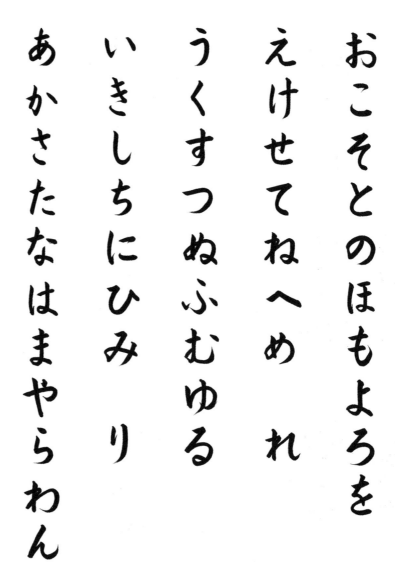

HIRAGANA

Hiragana (literally 'easy' or 'rounded' writing) was developed primarily through the private sphere, by women who were not typically schooled in formal kanji. Early all-kana texts were labelled *onnade* (women's writing). The most famous was Japan's first novel, *The Tale of Genji*, written in the 11th century by Murasaki Shikibu, a lady-in-waiting to the Empress Shōshi. Perhaps because of these roots, writers sometimes choose hiragana to add a warm, personal tone. More functionally, the syllables are also used for particles and grammar – to make a kanji verb past tense, for example. Traditionally hiragana was taught according to the iroha poem, but now it and katakana are written as *gojuon* (fifty sounds), in a five-by-ten grid with a few gaps and an outlier *n* sound with no associated vowel.

オコソトノホモヨロヲ
エケセテネヘメレ
ウクスツヌフムユル
イキシチニヒミリ
アカサタナハマヤラワン

KATAKANA

Katakana syllables ('partial' writing), which look like bare-bones elements of kanji, were initially a scribal cheat for reading, written in the margins next to characters to indicate their pronunciation. The letters now convey a certain logic or rationality. They are used to spell borrowed foreign words, new slang and sounds in onomatopoeia (not to mention the international shruggie, ‾_(ツ)_/‾, the smiling face of which is the syllable pronounced *tsu*). Katakana can add emphasis, similar to using italics in Latin script, and when it is used for dialogue, it can indicate that a person is not speaking Japanese. And because the letters are sharp-edged and minimalist, they are often used on signs or in company names and logos, mixed with or replacing kanji, to be more easily read at a distance.

PROVERB

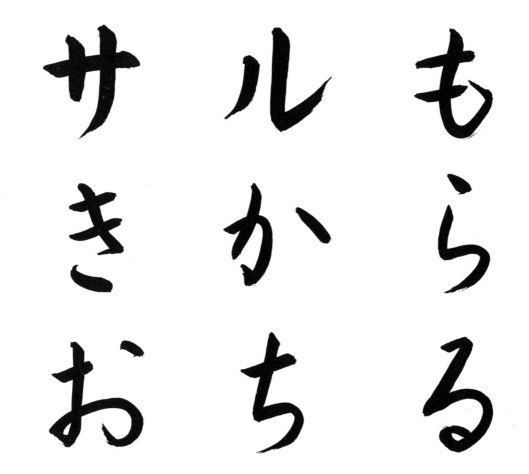

もらうるサルキおちかちる

EVEN MONKEYS FALL FROM TREES.

TRY ON THIS PAGE

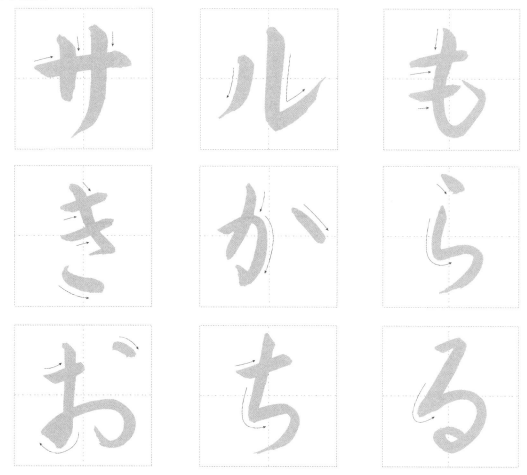

CALLIGRAPHY TOOLS USED:
Medium size brush, ready made black ink

JAVANESE

WHO & WHERE

Across Indonesia's scattered island geography, diverse scripts flourished for centuries. Starting in the 16th century, Dutch traders (later colonisers) brought the competing Latin alphabet, and a more definitive break came with World War II, when Japan occupied what was then the Dutch East Indies. As a security measure, all indigenous writing was summarily banned. At war's end in 1945, Indonesia gained its independence from the Netherlands, and the new government decided to unify the country's writing in Latin script, for use with the standardised lingua franca Indonesian as well as the numerous Austronesian languages specific to each island. Now only a handful of the old scripts are still extant. Of these, Javanese, spoken by some 80 million people on the island of Java, has the largest user base. The traditional Javanese script has also been used to write Madurese, spoken on the adjacent small island of Madura.

Javanese script, locally called *hanacaraka* (for its first five letters) or *aksara jawa* (Javanese letters), is, like all traditional scripts in Indonesia, derived from ancient Brahmi via a script called Kawi (from *kavi*, 'poet' in Sanskrit), which is also the source of most of the traditional scripts in the Philippines. It flourished in the royal court at

Yogyakarta starting in the 17th century, when the Mataram sultanate ruled central Java. The script and spelling was standardised in 1926, but the war soon followed, and very little has been published in the script. Writing is now promoted through school, where children learn the letters alongside Latin ones. Daily use remains limited to official and semi-official contexts, such as street signs in Yogyakarta and Surakarta, and family names on houses in villages.

Other traditional Indonesian scripts are somewhat less visible, but revival movements are afoot. The west end of Java island officially adopted Sundanese script in the mid-1990s, after a 200-year dormancy. Javanese's sister script, Balinese, diverged only in the early 19th century, when a different typeface was developed. It received a big political push in 2018, when Bali's new governor instituted 'traditional Thursdays', for which Balinese Hindus are encouraged to wear traditional dress and speak Balinese. This builds on an existing network of local reading groups, in which members gather to recite from older Kawi texts and translate them into the Balinese language. The script is also used on nearby Lombok, for the language of Sasak.

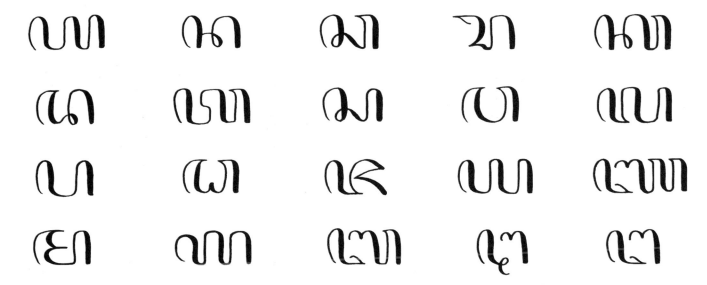

HOW TO USE IT

Javanese is one of the most ornate and subtle of all the Brahmic scripts. Composed largely of 'hills' and 'valleys', with few other distinctive shapes, the letters can be almost indistinguishable to an untrained eye, especially in modern typefaces, where the letters are all roughly the same height. In old manuscripts the space between lines is very large, to leave room for great swooping ascenders and descenders, which resemble the long, skinny arms of Javanese shadow puppets.

In its most basic form the Javanese syllabary has 20 consonants, shown above, each with the inherent vowel *a*. When read in their traditional order, they make a simple poem, a perfect pangram:

hana caraka (there were two messengers)
data sawala (they had a disagreement)
padha jayanya (they were equally powerful)
maga bathanga (here are the corpses)

The story is part of the larger tale of Aji Saka, the legendary first king of Java; the two messengers were servants who, in their dedication to the king's orders, mistrusted each other. According to the tale, Aji Saka composed the poem in their honour.

Each consonant has a second form with no vowel, called a *pasangan* (pair). Smaller and somewhat altered from its source letter, the *pasangan* is used in consonant clusters, set below (or sometimes, with a grand flourish, to the right of) a preceding consonant to indicate that there is no intervening vowel.

There is also an elaborate third form, called *murda*, used as a kind of honorific when spelling distinguished names. Only ten consonants have a *murda* form, so if the first syllable of the name is a letter without one, then the *murda* is used wherever one next appears in the name.

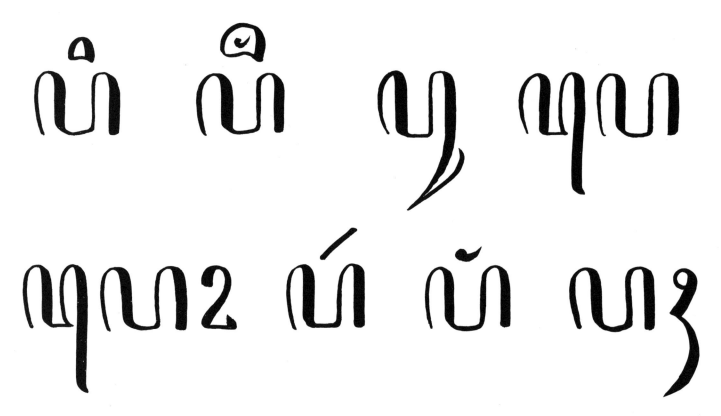

SANDHANGAN

Javanese, like other Brahmic scripts, relies on a set of diacritics to change the inherent vowel of the consonant letters. These marks are called *sandhangan*, literally 'clothes'. The mark can be a simple outfit, changing a short vowel: *pa* to *pi*, for instance, with a large circle above (top row). Or it can be a more elaborate change, such as adding a final sound to the syllable: *pa* to *par* (the short line above the letter in row 2), for example, or *pa* to *pang* (with the small curl).

Stand-alone vowel symbols (called *swara*) exist, but they are not commonly used. When a word begins with a vowel, the consonant *ha* stands in. When a word ends with a consonant, the mark added to silence the inherent vowel (the rightmost symbol in row 2) is called a *paten* or *pangkon*. The latter means 'lap', because the mark curves back, giving the preceding consonant something on which to sit – and, presumably, be comfortable and quiet.

LONTARA

In contrast with the ornate swoops and curves of Javanese and Balinese, Lontara, used on the island of Sulawesi, is strikingly minimalist – although it too derives from Kawi (and Brahmi). Its 23 consonant symbols, each with the inherent vowel *a*, include several common consonant clusters (*mpa*, for instance, the rightmost letter in the second row), to compensate for the lack of any vowel-killing notation. Lontara is also called Bugis or Buginese, for one of the three languages that uses the script. (The other two are Makkasarese and Mandar, drops in the sea of the more than 700 languages in Indonesia.) The word *lontara* also refers to an important collection of manuscripts on paper made from the palmyra palm (*lontar*). These manuscripts detail the battles, traditions and legends of the Bugis people.

PROVERB

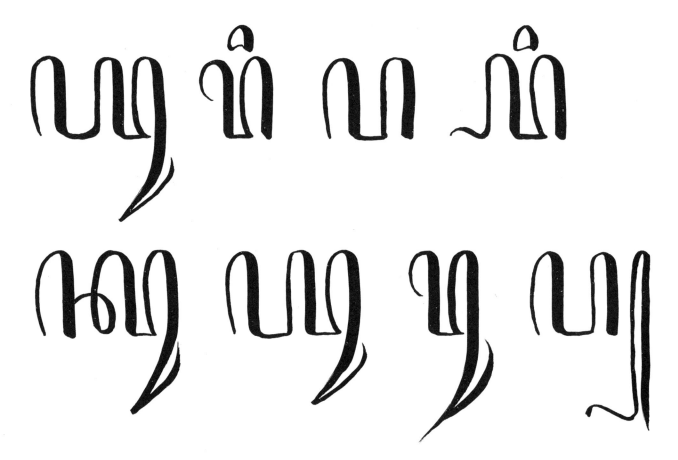

TO LIVE IS TO BE A FLAME.

TRY ON THIS PAGE

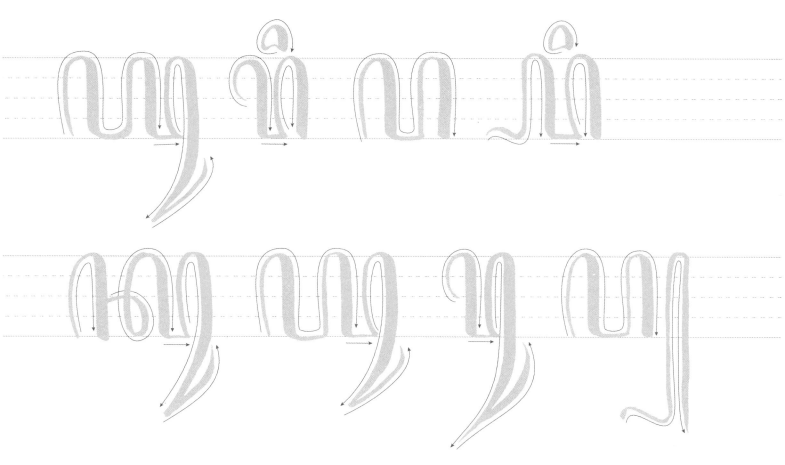

CALLIGRAPHY TOOLS USED:
Pigma Micron Brush

KHMER

WHO & WHERE

Khmer writing is the oldest script in Southeast Asia still in use. The script has about 11.4 million users in Cambodia, tiny pockets of Thailand and Vietnam, and the diaspora. The Khmer people – virtually synonymous with Cambodia, as they make up 97 percent of the population there – trace their mythical origin to the marriage of an Indian Brahmin priest and a half-snake Naga princess who lived on an island. The princess's father drank the water around the island, revealing it to be the top of a mountain; the land at the base of the mountain was the princess's dowry, now Cambodia.

The early Buddhist kingdom of Funan reigned on the Mekong Delta from the 1st to the 6th century AD. It is considered a kind of mother culture for greater Southeast Asia, and the source of Old Khmer script, which spread – through trade and Buddhist practice – to what is now Thailand and Laos.

Khmer script has its roots in India, in the Brahmi script – although it barely resembles it today. The letters shifted to their current shape during Cambodia's golden age, the 12th-century reign of King Suryavarman II, who built the massive temple complex Angkor Wat. Khmer monks adapted Chinese papermaking to local materials such as rice plants and the bark of the *khoi* tree, and began producing lavish accordion-fold books.

All this heritage was nearly destroyed during the Khmer Rouge period in the mid-1970s. Dictator Pol Pot burned the palm-leaf and paper books in monasteries, killed 90 percent of the nation's artists and writers, and housed pigs in the National Library. He also sought to eradicate folk culture, which included more popular writing traditions like comic books and even *sak yant* protective tattoos of Buddhist Pali prayers written in Khmer script.

But Cambodian writing culture revived almost as soon as Pol Pot was ousted. At first writers hand-wrote pulp serial stories and peddled them in markets. Then they turned to memoirs, poetry and new novels (the word for novel, *pralomlok*, literally means a story to seduce the heart). As for some of Cambodia's older works that have been permanently destroyed, at least they are preserved indirectly, through their ancient influence and the traditions that spread to neighbouring countries.

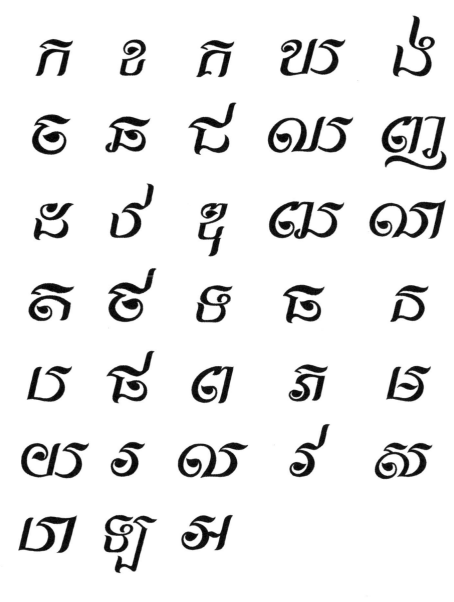

HOW TO USE IT

Like all Brahmi-derived scripts, Khmer is a syllabary, though the inherent vowel on its 33 consonants (shown here) can be either *a* or *o* – or in the case of *k* and *kh*, both. Consonants also have a subscript form, for use when combining them in a stack with preceding consonants, with no vowel in between. Khmer is not tonal, but it has a broad range of vowel sounds, written with 14 independent symbols (called 'complete' vowels) or, more commonly, 21 diacritics that can appear above, below or on either side of the consonant.

Khmer also has a large set of symbols. One doubles words, to make plurals; another marks a change of subject. Religious texts end with the less-than-holy-sounding *koumot* (cow urine) symbol: a spiral spinning out into a long wiggly line. Pronunciation has changed significantly in a millennium and a half, so many words are not spelled as they are spoken. To help, there's a *tondakheat*, which resembles a tiny lounge chair, perched above final syllables that are no longer pronounced.

Handwriting is in a slanted style called *aksar chrieng* (although it is also commonly printed). Letters are written in a specific order, starting first with the consonant, then adding the vowel, which requires practice to get the spacing right. There is no space between words, but there is space between sentences.

PROVERB

ស្រឡាញ់កូនមួយថៅ

ស្រឡាញ់ចៅមួយថាំង ។

LOVE YOUR CHILDREN TWO PECKS.
LOVE YOUR GRANDCHILDREN A WHOLE BUSHEL.

TRY ON THIS PAGE

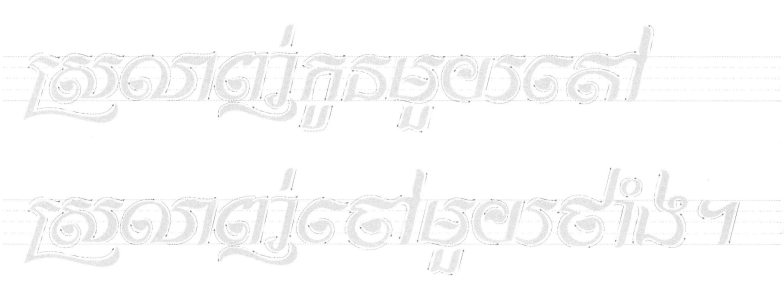

CALLIGRAPHY TOOLS USED:
Black ink pen

MONGOLIAN

WHO & WHERE

The Mongolian language has been written in more than ten scripts over its history – a disproportionately large number for a somewhat obscure language spoken by only about 5.2 million people in Mongolia, China and Russia. This script diversity is a legacy of the great Mongol Empire, which, under Genghis Khan and his offspring, stretched from the Pacific Ocean to the Mediterranean Sea. In the western reaches, Mongolian has been written in Arabic; in the east, the 13th-century text *The Secret History of the Mongols* now survives only in Chinese characters. More recently Cyrillic became the standard writing system after the nation of Mongolia was annexed by the Soviet Union.

Through all this, however, the most persistent and consistent system for writing Mongolian is a script commissioned by Genghis Khan himself. In the early 13th century, the emperor attacked a rival tribe and captured a man named Tata-tonga, a professional scribe. Tata-tonga was put to work and devised what came to be known as *mongol bichig* by adapting Old Uyghur, which was in turn derived from Sogdian and Aramaic. The Middle Eastern link helps explain why Mongolian looks a bit like Arabic turned on its side.

Ironically the Mongolian script persists not so much in the nation of Mongolia itself – where Cyrillic remains the dominant script, even post-USSR – but in the Inner Mongolia Autonomous Region of China. Here *mongol bichig* is part of the school curriculum, and in Hohhot, the capital of Inner Mongolia, businesses have signage in both Chinese characters and the spiky lines of Mongolian; Starbucks prints its receipts sideways to accommodate the vertical script.

There are two other outposts of Mongolian script: the Kalmykia and Buryatia regions of Russia, where Oirat and Buryat (also in the Mongolic language family) use a later variant of Mongolian script, *tod bichig*. This 'clear script' was devised by a Buddhist monk in 1648 to solve the ambiguities of Tata-tonga's system and render religious texts in Sanskrit and Tibetan. Finally, in Siberia and China, Manchu also uses a variation on *mongol bichig*, although Manchu is so obscure that it has just a handful of remaining native speakers.

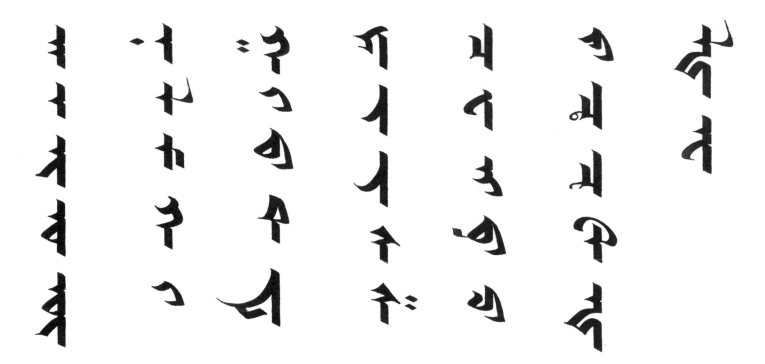

HOW TO USE IT

The *Mongol bichig* alphabet is the only vertical writing system that's read from left to right. Like Arabic letters, Mongolian ones are written in cursive, and their shape varies according to whether they appear in the beginning, middle or end of a word. The set shown here, used in Inner Mongolia, shows the letters in their initial form. To facilitate reading the connected letters, students often learn them as a syllabary

– that is, a table of common consonant-vowel combinations.

The script took its angular quality when written with a reed pen and printed with carved wood blocks. In the 18th century the Mongols came under the Qing dynasty, and scribes adopted Chinese calligraphy brushes, lending the script a new, fluid form. In 2013 Mongolian calligraphy was added to UNESCO's list of intangible

cultural artifacts, and the art has helped revive interest in the script in Mongolia, after decades of Cyrillic use.

Writing falls along a central line, called a spine; key letter shapes are also named for body parts: the notch-like 'tooth', the longer 'shin', the circular 'stomach', and the curving 'tail' on some final-form letters. The end of a sentence is marked by two dots; the end of a paragraph, by four.

PROVERB

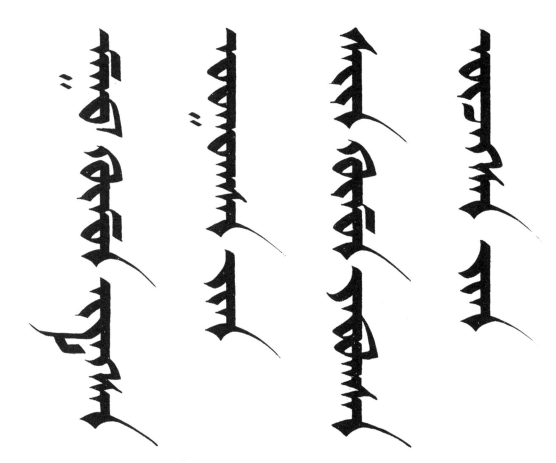

THE BAD PERSON TALKS ABOUT WHAT HE ATE AND DRANK.
THE GOOD PERSON TALKS ABOUT WHERE HE WENT AND WHAT HE SAW.

TRY ON THIS PAGE

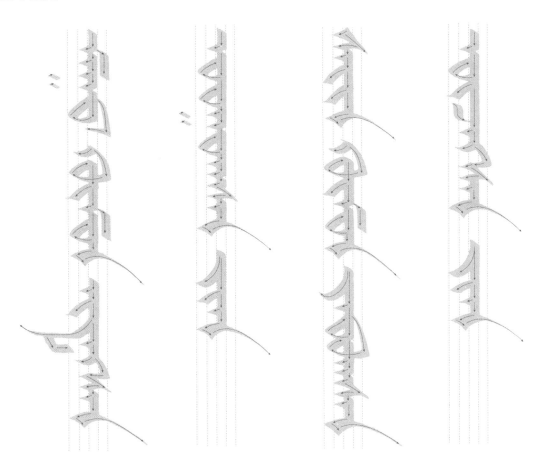

CALLIGRAPHY TOOLS USED:

Flat marker

N'KO

WHO & WHERE

In 1944 a 22-year-old Guinean merchant named Souleymane Kanté, browsing a book stall in Côte d'Ivoire, picked up a collection of African reportage by Lebanese journalist Kamel Mrowa. In one essay Mrowa compared African languages to 'those of the birds – impossible to transcribe', and claimed that Africans, lacking literature, were cultureless. Mrowa was by then busy establishing a newspaper in Beirut and likely never thought of his dismissive words again – but Kanté, incensed by the insult, set out to prove Mrowa wrong. In the process, he made a lasting contribution to West African literacy.

Kanté, whose father was a schoolteacher, tinkered for several years, and in 1949 introduced a script for his native language of Dyula. He named his invention N'Ko, which means 'I say' in the larger Manding language family and is a kind of cultural identifier. Famously, Mali's 13th-century emperor, Sundiata Keita, addressed his army: 'I am speaking to you, valiant men, to all those who say "N'ko," and to those who don't.' As people started learning the script, Kanté became a kind of folk hero, and the story of his invention was memorialised in an epic poem.

The core users of N'Ko are still primarily some of the 2.2 million Dyula speakers in Guinea and Côte d'Ivoire, but the script has also been adopted for other Manding languages: Bambara in Mali, and, to a lesser degree, Yoruba and Fon in Benin and Nigeria respectively. A distinct written language, called *kangbe*, or 'clear language' (from Kanté's coined term for grammar), has evolved as a kind of compromise among all the variants. N'Ko script unites all those people in writing, as well as speech.

Although N'Ko is relatively new, it has nonetheless become very well used in just a few decades. N'Ko's arrival in the age of type – and, not too much later, digital communication – has almost certainly helped its spread. Kanté immediately commissioned dedicated typewriters for the N'Ko alphabet. Later, one of his students developed the first digital fonts. Although Latin letters are still much more common across West Africa, N'Ko's influence and use may actually be expanding. It is now used on websites and for text messages; there are even dedicated cellphone apps for N'Ko keyboards.

HOW TO USE IT

N'Ko is an alphabet with seven vowels (the top row of letters here) and 20 consonants. It somewhat resembles Arabic script, in that the letters are connected along the baseline. Unlike Arabic, however, the letter shape does not vary according to its position in the word.

Also like Arabic, N'Ko is written from right to left. According to the folk history of Kanté, the text direction was based on Kanté's informal surveys of villagers, whom he asked to 'write' in the dust with a stick – most often, they chose to make marks from right to left. (Interestingly, unlike Arabic, N'Ko's distinct numerals are also written right to left.)

As important to N'Ko as the letters are its accent marks, which distinguish long and short vowels, as well as the four tones (high, low, rising and falling) used in all Manding languages. These accents (again unlike Arabic) are not considered optional. They distinguish, for example, the word for 'porcupine' from the word for 'horse'. A dot below a vowel indicates a nasal pronunciation. Added to the vertical vowel *a*, this creates a combination that looks like a Latin exclamation point. An N'Ko exclamation point is actually two dots topped with a short horizontal line.

PROVERB

IF YOU SEE YOUR FRIEND WEARING YOUR ENEMY'S SHIRT,
IT'S TIME TO SPLIT.

TRY ON THIS PAGE

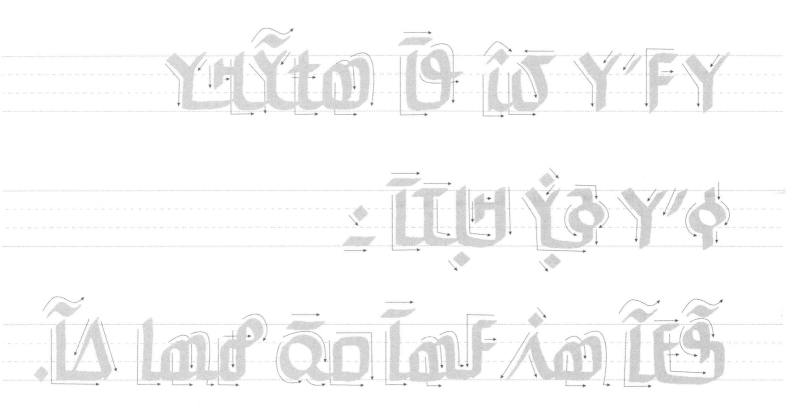

CALLIGRAPHY TOOLS USED:
Black non-waterproof ink and Pilot Parallel Pen 3.8mm

SYRIAC

WHO & WHERE

A product of overlapping layers of culture in the Middle East, the Syriac script does not align neatly with a single language or ethnic, religious or national identity. Approximately 2 million people around the world, primarily but not exclusively Christian, speak a number of neo-Aramaic languages – contemporary versions of this ancient language of the Fertile Crescent. Of the various communities in Turkey, Syria, Iran, Iraq and the diaspora, some now use the Latin alphabet, but many use one of several versions of the Syriac script.

Aramaic is a Semitic language with roots in the Biblical land of Aram, now Syria, and spoken across the Middle East for millennia – most famously by Jesus, who spoke the Galilean dialect. It was written as early as the 10th century BC, based on Phoenician letters, and it gradually took on two forms: block letters, used in stone inscriptions (these square letters later evolved into the Hebrew alphabet), and a more fluid cursive.

The Syriac language began as a dialect of Aramaic, in the city of Edessa – now Urfa, Turkey – in the 1st century AD. Here also evolved a distinct version of cursive Aramaic: classical Syriac script.

A Syriac translation of the Old and New Testaments (from Hebrew and Greek) may have been made as early as the 2nd century; certainly one was fully codified by the 5th century.

From the 4th to the 8th century, Syriac was a lingua franca in the Middle East, from Antioch (Antakya, Turkey) to what's now far eastern Iraq, and the Syriac script was used for literature of all kinds, by people of many different backgrounds and religions. With the expansion of Islam in the 7th and 8th centuries, Arabic gradually replaced Syriac. For a time, before the Arabic abjad was standardised, the two systems overlapped in *garshuni* – Arabic-language texts written in Syriac letters. In India the Saint Thomas Christians of Kerala wrote Malayalam in Syriac letters until the early 20th century.

Though endangered, Syriac script is still used in both religious and secular contexts. Classical Syriac is also the liturgical language in several Eastern rite churches, and taught in some schools in Iraq and India. Mandaic, a cousin of Syriac also developed from cursive Aramaic, is used by adherents of Mandaeism, a gnostic religion practised in Ahvāz, Iran, southern Iraq and in the diaspora.

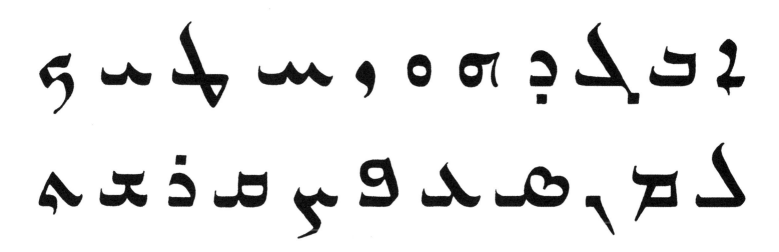

HOW TO USE IT

The Syriac abjad is 22 consonants, written right to left. Like Arabic, the letters are written in a cursive style, almost all connected, and, like Arabic, three of the letters can double as long vowels. Some letters take a slightly different form at the end of a word. Short vowels are marked with small diacritics placed above and below consonants – a system that was probably the inspiration for similar notation in Arabic and Hebrew, all of which shared a geographic region and the parent script Aramaic.

Dots are used to distinguish between a few sets of consonants. 'Hard' letters such as b and g are turned into their 'soft' counterparts, v and gh respectively, with the addition of a dot beneath and just to the right. 'Hard' consonants are optionally marked with a dot above and to the right. This system was adopted in Hebrew as well, for the same letters: 'begadkefat' is a mnemonic for the six hard consonants. Additionally, two dots (or sometimes one) are used to mark a plural. Perhaps to avoid a confusing pile-up of dots, the pluralising marks can be placed above almost any letter in a word.

Syriac script has changed dramatically in its long history, and there are three versions of it: classical Estrangela, no longer used, and Madnhaya (shown above) and Serta. At first glance, they might not look related, nor do they resemble square Aramaic (sometimes called Imperial Aramaic) or Hebrew, to which they are also related. Classical Syriac, or Estrangela from the Greek word for 'rounded', has a thin, spidery quality that makes its common name somewhat misleading. This original form of the script is purely the domain of scholars. Today's speakers of neo-Aramaic use Serta in the west and Madnhaya, to the east.

PROVERB

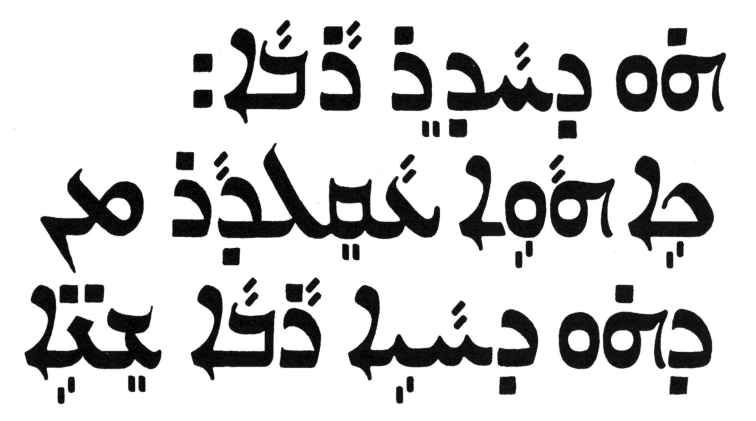

HE WHO TRAVELS MUCH IS WISER THAN
HE WHO LIVES TO A GREAT AGE.

TRY ON THIS PAGE

CALLIGRAPHY TOOLS USED:
Reed kalam, Turkish ink

TAMIL

WHO & WHERE

Of India's 700-plus languages, most fall into two families: the Indo-Aryan languages spoken across central India (such as Gujarati, Hindi and Bengali), and the Dravidian ones, which dominate the south of the country. Perhaps following this bifurcation, the ancient Brahmi script split by about the 3rd century BC into northern and southern variants. Today the most widespread child system of South Brahmi is Tamil, with some 70 million users in southeastern India and the north and east of Sri Lanka. It's also taught in Tamil communities in Canada and Malaysia.

Over the past century, Tamil activists have worked to carve out a sphere of influence for the language, separate from dominant Hindi (and its Devanagari script) in India, as well as from Sinhalese in Sri Lanka. The Pure

Tamil Movement purged Sanskrit loan words from the vocabulary and promoted Tamil as a writing system with a deep history that rivals Devanagari's. In 1956 a campaign succeeded in changing the name of the prosperous and densely populated state of Madras to Tamil Nadu (Tamil country) and establishing Tamil as the co-official language, with English – and, pointedly, *without* Hindi, a legal situation that is unique in India. The movement peaked in fervour in the 1960s, when two people were killed at anti-Hindi demonstrations.

Over the decades Tamil language activists have smartly promoted both literary and daily writing in the script. In 1942 a London-trained lawyer established *Dina Thanthi*, a broadsheet modelled on British tabloids (its name in fact means 'Daily Mail'), with salacious stories of

murder and scandal in Chennai's glamorous film industry. The publisher's express goal was to make the Tamil language and script widely accessible and to encourage the habit of daily reading. It's still the largest Tamil newspaper, and Tamil Nadu has a literacy rate far above India's median.

In the literary sphere, activists succeeded in 2006 in having Tamil inscribed in the constitution as a 'classical language' of India, alongside Sanskrit. This honours, among other cultural contributions, the massive anthology of poetry called Sangam literature, named for semi-mythical conventions of literati in Tamil history. The poetry spans six centuries, from approximately 300 BC to 300 AD, and includes verses by more than 500 writers on the whole range of human experience.

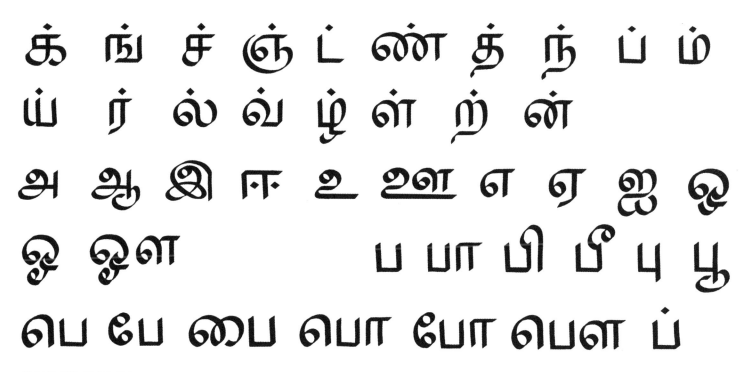

HOW TO USE IT

Tamil, like Devanagari, to which it is related, is a syllabary, with 18 consonants (called 'body letters', the top two rows above) with an inherent vowel a, and 12 vowels ('soul letters', third row and left part of fourth). To modify a consonant's vowel, a smaller vowel form is attached (the fourth and fifth rows, with the letter pa). The result is some 216 letter forms. Tamil script differs from Devanagari in having no conjunct consonant forms. Instead, two consonants are simply written adjacent, and a small dot called a *pulli* is placed above the first. The *pulli* is a relic of an ancient form of Tamil, found in rock inscriptions from the 2nd century BC but disused for many centuries.

When palm-leaf paper came into use in the 6th century AD, Tamil scribes had to develop special writing techniques for the new medium. Because the tool used to incise letters was so sharp, the *pulli* dot would have poked a hole in the fragile paper, so it was abandoned. Letter shapes also turned rounder, to avoid straight lines that would cut the palm leaves. Many centuries later, with the arrival of different papers and modern typesetting, the *pulli* was restored.

PROVERB

கற்றது கைமண் அளவு, கல்லாதது உலகளவு

WHAT WE HAVE LEARNED IS A HANDFUL OF SAND.
WHAT IS STILL UNKNOWN IS THE WHOLE WORLD.

TRY ON THIS PAGE

CALLIGRAPHY TOOLS USED:

Parallel pen

THAI

WHO & WHERE

The Thai script, used by about 38 million people across Thailand and, in a modified form, in neighbouring Laos, was developed on the order of King Ram Khamhaeng of Sukhothai and adopted in 1283. The new script was a symbol of independence from the neighbouring Khmer empire, of which the Tai people had been a part for centuries before the foundation of the Kingdom of Sukhothai. Thai writing was based on Old Khmer script (which came from Brahmi), but it required significant adaptation to reflect the Thai and Lao languages, which are in a different family from Khmer. Most important, Thai and Lao are tonal, while Khmer is not. Thai script developed four tone marks, making it the first writing system in the world to express tones.

The evidence for the Thai script's origin is a stele dated 1292 and inscribed with Ram Khamhaeng's various achievements in Sukhothai, the kingdom named the 'dawn of happiness', which is generally considered the first Thai state. In the 1980s the stele's glowing narrative was cast in shadow when an Australian researcher charged that, based on the inscription's not-very-13th-century writing style, it might be an elaborate forgery. A Thai art historian took the issue further, asserting that the forgery was done by none other than the beloved King Rama IV (known to Westerners through the musical *The King and I*), who discovered the stele personally in 1833 when he was a young prince and monk. The question remains open, although analysis with an electron microscope at least provided enough evidence to have the stele registered in UNESCO's Memory of the World programme in 2003.

Aside from the debate about its origins, Thai script has evolved smoothly from stone carving to contemporary use. It helps that it lacks special consonant ligatures or stacks, as many other Brahmic scripts do. Its superabundance of consonants, on the other hand, did pose a challenge to the American designer of the first Thai typewriter, which was introduced in 1892. Even with double the number of keys as on a Latin-alphabet machine, the device still left off two obscure consonants, *kho khon* and *kho khuat*. With digitisation, the letters are accessible again, and – although no words use them anymore – sometimes they're added to text to give an old-fashioned look.

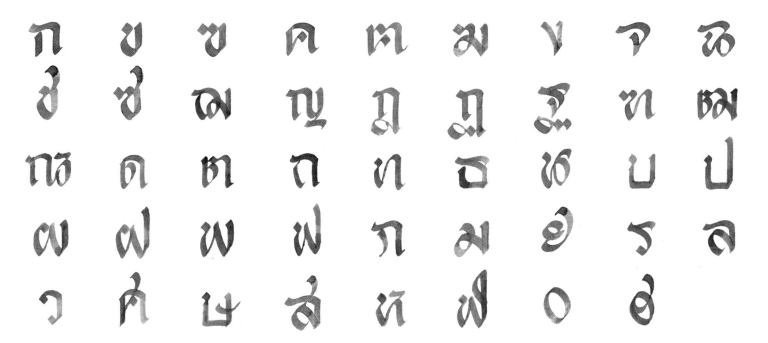

HOW TO USE IT

The Thai syllabary consists of 44 consonants (shown here), plus 15 vowels and 28 other assorted vowel symbols. The consonants have an inherent vowel o (or a at the end of a word), as well as an inherent tone, which varies. The four innovative tone markers shift the consonant's inherent tone up or down the scale.

To make room for the tone markers, Thai dispenses with some conventions found in other Brahmic scripts, especially stacking or combining consonants. All Thai letters stand alone, written on a single baseline, from left to right. There are typically no spaces between words, except small ones where commas might go, and a regular space between sentences.

As a memory aid, each letter is named for an object: go gai (chicken go) is the first letter, for example, and kho khai (egg kho) is the second. The letter names also help clarify spelling, which has become complicated over the centuries as Thai's distinct sounds have shrunk from 44 to 21. So there are redundancies: kho khai sounds the same as kho ra-khang (bell kho) and kho khwai (buffalo kho) – not to mention the two obsolete khos. The very similar Lao script has undergone more aggressive reforms: it has only 27 consonants, and far fewer opportunities for misspelling.

PROVERB

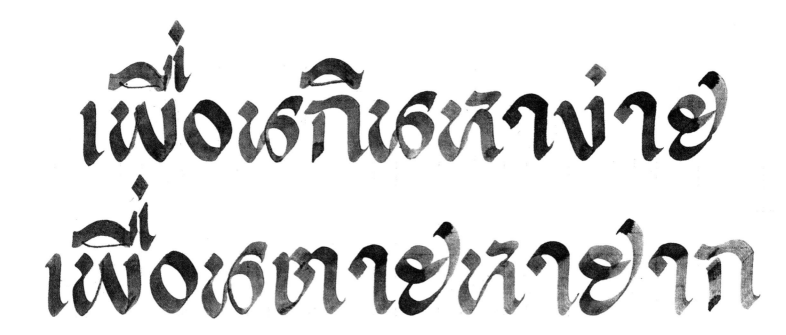

FRIENDS FOR A MEAL ARE EASY TO FIND.
FRIENDS FOR LIFE ARE HARDER TO FIND.

TRY ON THIS PAGE

CALLIGRAPHY TOOLS USED:
Parallel pen 3.8mm

TIBETAN

WHO & WHERE

The Tibet Autonomous Region of China is the centre of Tibetan language and script. But with the large diaspora, it is used by about 6 million people around the world – especially in neighbouring Nepal, India and Bhutan. As the language spread across the rugged and impassable Himalayas, Tibetan developed into discrete dialects and even separate languages, such as Dzongkha (spoken in Bhutan) and Ladakhi (in India). All share the Tibetan script, as well as a common written form of the language, similar to the way Arabic dialects vary but its script and written grammar and vocabulary are mostly standard. Similar to the relationship between Arabic and the Qur'an, Tibetan language and script are tightly connected with Tibetan Buddhism.

The Tibetan script's status within China is maintained by law, as part of the Seventeen-Point Agreement signed in 1951. The contentious treaty established Chinese dominion over Tibet, while promising protections for Tibetan ethnicity and culture, such as teaching the Tibetan language – at least through primary school. Secondary education is almost entirely in Mandarin, and Chinese culture and writing is very visible in the region's two largest cities, Shigatse and Chamdo. In rural areas Tibetan for the most part remains the dominant language.

Tibetan writing is said to have started in the mid-7th century AD, when the ruler Songtsen Gampo was expanding his territory beyond the plateau around Lhasa – the first steps to what would become the Tibetan Empire, stretching across the Himalayas and east almost to Chengdu. Gampo sent a young minister, Thonmi Sambhota, on a scholarly mission to India. Sambhota returned with the Gupta script (derived from ancient Brahmi), which he adapted to the Tibetan language, specifically for the Buddhist texts that King Gampo then introduced to his people.

Sambhota's Tibetan script, in turn, inspired others. In the 13th century another Tibetan scholar, 'Phags-pa, was commissioned by Kublai Khan to design an alphabet for Mongolian. The 'Phags-pa 'square script', which resembles Tibetan written vertically, was used only for about a century in the Mongolian court, but in that time, its shapes may have inspired King Sejong of Korea when he was designing Hangul.

HOW TO USE IT

Read left to right, the Tibetan syllabary has 30 consonants, each with the inherent vowel *a*. Compound consonants can be stacked, as in many other Brahmic scripts, and four diacritics change the vowel shape. A *tsek*, a small triangular mark, is set between syllables at the level of the headline. A long vertical line marks the start and end of a topic. Where Tibetan pronunciation has changed drastically, writing conventions have not, so words are packed with no-longer-pronounced consonants. *Gye* (eight), for example, is actually spelled with five consonants: *b*, *r*, *g*, *y* and *d*.

The pointed letters and long descenders perhaps developed because the letters were first carved in woodblock prints. Later, Tibetan scribes adopted bamboo pens. Although they used local materials for paper, their book forms imitated the palm-leaf-paper Buddhist manuscripts of South Asia, with long, thin loose-leaf pages. Tibetan books are often solid black pages, with yellow or gold writing.

Tibetan writing has two main styles: *uchen*, which has a headline connecting the letters, like Devanagari, and *umê*, which does not. Traditionally *uchen* was reserved for religious writing (it's seen on Tibetan prayer flags, for instance), and cursive *umê* was used in secular contexts – but that distinction has faded as now most typefaces are based on *uchen*.

PROVERB

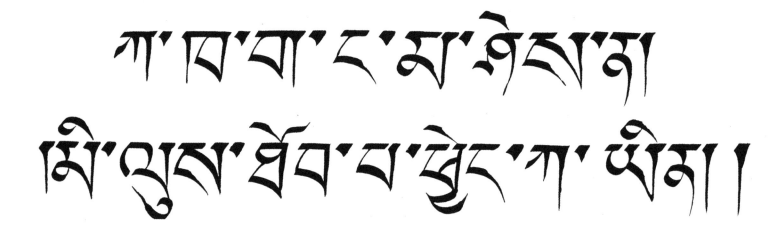

IF ONE DOES NOT KNOW THE ALPHABET,
ONE HAS LIVED ONLY HALF A HUMAN LIFE.

TRY ON THIS PAGE

CALLIGRAPHY TOOLS USED:
Reed pen with tip cut in a flat manner

TIFINAGH

WHO & WHERE

Tifinagh is the writing system historically used by the Imazighen, the native word for the people whom Europeans named Berbers. For millennia, the Imazighen (literally 'free men'; the singular Amazigh is also used) have lived in North and Saharan Africa – from the Canary Islands to the Western Desert of Egypt, and as far south as Burkina Faso. The word Tifinagh reflects the script's ancient roots: it may mean 'the Phoenician', referring to the script's likely inspiration, the Phoenician alphabet. It can certainly be traced back to a possible intermediate writing system, Libyco-Berber, from the 3rd century BC. Tifinagh symbols still in use today can be seen in southern Algeria adorning the 4th-century-AD Tomb of Tin Hinan, a Tuareg queen.

Starting in the 7th century, the expansion of Islam brought the Arabic language and script, which gradually edged out Berber languages and Tifinagh writing among others. Under European colonialism French, Italian and English pushed the Berber languages further aside. In the mid-20th century Amazigh culture was considered a threat to the unity of newly independent countries, and to the grand project of Arab nationalism, which attempted to rally a huge region under the banner of Arabic and Arab culture. In some North African nations Berber languages and Tifinagh letters were banned outright, and Amazigh activists were jailed.

Even so, a majority of Moroccans and about a third of Algerians identify as Amazigh. Total population estimates range from 20 million to 50 million, including a diaspora in Europe (most famously footballer Zinedine Zidane). A smaller number of people, numbering anywhere from 14 million to 25 million, regularly speak a Berber language, and a far smaller portion use Tifinagh to write.

Recently there has been a massive shift, at least in linguistic terms: Berber languages were made official in Morocco in 2011 and in Algeria in 2016. The use of Tifinagh in those countries is still largely symbolic, gracing government buildings and official paperwork, as well as shop signs and advertisements. Perhaps the greatest symbolic use is on the flag of the Imazighen: in the centre is the Tifinagh letter *yaz*, which resembles a person, arms raised up.

HOW TO USE IT

Traditionally, Tifinagh has been an abjad: consonants only, with vowels implied or optionally marked. It was used for various dialects, in discrete communities spread across a huge area, from the Tarifit dialect of Morocco's northern Rif mountains, to Taqbaylit in Algeria's Kabylia region, to Tamashek, spoken by the Tuareg in the deserts of Mali and Niger. As a result, different sets of Tifinagh letters developed over time. Spelling conventions also vary, because Tifinagh has primarily been used for personal communication; the small body of existing Berber literature is in Latin letters.

With Tifinagh now legally accepted in Morocco and Algeria, there has been a fresh push for a standardised common language (typically called Tamazight), so that it can be more consistently taught, spelled and printed. Out of this has come Neo-Tifinagh, which is an alphabet, with stand-alone symbols for vowels. Yet even Neo-Tifinagh shows some variation. The most widespread version is probably the one shown here, a 33-character alphabet called Tifinagh IRCAM, because it is endorsed by Morocco's Institut Royal de la Culture Amazighe. Established in 2001, IRCAM is the primary institution overseeing the Tamazight curriculum. Posters of its alphabet hang in classrooms across Morocco, in contrast with a few decades ago, when Arabic was the sole language of instruction.

As for the direction of writing, that too was nonstandard for centuries, running in all directions. Modern writing is horizontal, running left to right.

PROVERB

HE WHO IS BITTEN BY A SNAKE FEARS A ROPE.

TRY ON THIS PAGE

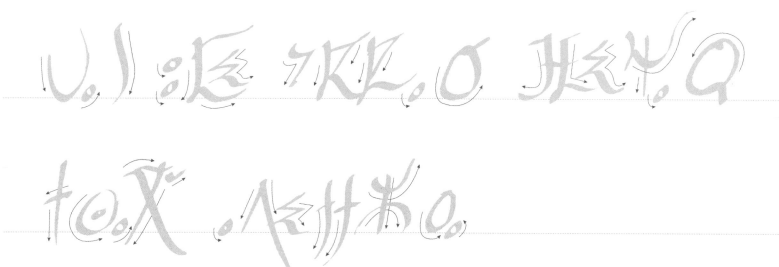

VAI

WHO & WHERE

In West Africa in the 19th and 20th centuries, new alphabets were something of a local crop. Dozens of systems sprouted as native speakers of African languages strove to improve on the Latin and Arabic letters that had come with colonialism, and to defend their own culture and traditions in the process. In the end, most of the new writing systems failed to take root, but the first – for Vai, devised in Liberia around 1833 – has also been one of the most successful.

Part of the Mande family, the language is spoken by the Vai people, who migrated from Mali to the Atlantic coast in the 16th century. It is a relatively small community of less than 200,000, with most in Liberia and a small portion in Sierra Leone. The inventor of Vai writing is Momolu Duwalu

Bukele, who, according to (ironically) an oral poem of the event, received inspiration for the script from a dream. Upon waking, he could remember none of the symbols, but he worked with six other men to create a set of letters: a syllabary, unlike the Latin alphabet or the Arabic abjad, which West Africans already used to write.

Bukele also established schools for teaching the script, and by the end of the 1800s, literacy rates were solid among the Vai, who found the script aided their trade with the Dutch and Portuguese. Bukele's syllabary was employed to record the history of the Vai clans, including the migration from Mali, as well as their folk tales and religious texts. Literacy rates slipped in the 20th century, and Latin

letters still dominate, but with digitisation, usage of Vai symbols has risen again.

More recent research has introduced the possibility that Bukele was inspired by Sequoyah's Cherokee syllabary, published in 1821. News of the script could have been carried by missionaries, via American newspapers available in Liberia at the time, or even by a single Cherokee man, Austin Curtis, who moved to Bukele's town a few years after the Cherokee syllabary was introduced. Curtis married into a chief's family, learned Vai and almost certainly knew Bukele. The connection is only circumstantial, but nonetheless a tantalising explanation for Bukele's syllable-based approach, unique in West Africa when it was introduced.

HOW TO USE IT

In Bukele's original formation, the Vai syllabary had 212 symbols. The earliest texts also used a handful of logograms, symbols that represented entire words. The logograms fell out of use, and a conference of academics in 1962 standardised the syllabary to 205 characters (a modified version is shown here), in a syllabary table of 40 consonants with up to seven vowel sounds. Each of the seven vowels also has a stand-alone form and a nasalised form.

In most alphasyllabaries, each consonant is transformed according to the associated vowel sound – that is, a pattern can be seen reading across a row. Vai takes a different tack, and not very consistently. The patterns that do exist are in the vertical columns, between consonants that share the same vowel. The u column (the rightmost of seven) is marked occasionally by a fish-hook shape, for instance. The last row, for the consonant z, has a few shapes in common with the row for s, six above.

A set of Vai numbers was proposed in the 1920s, but they have not been adopted; Arabic numerals are used instead. Likewise Bukele's punctuation marks – a large asterisk for a full stop, for example – which have largely been replaced with Latin equivalents.

PROVERB

SAYING 'HONEY, HONEY' IS NOT WHAT BRINGS
SWEETNESS TO THE TONGUE.

TRY ON THIS PAGE

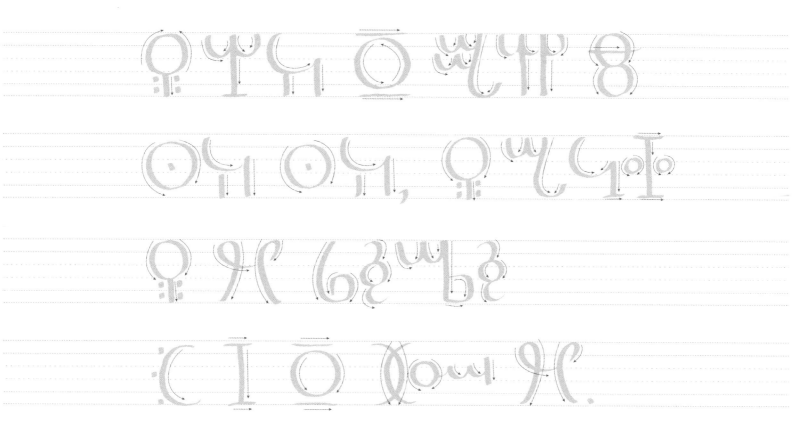

CALLIGRAPHY TOOLS USED:
Square pointed nib tip pen

GLOSSARY

abjad – a writing system with letters for consonants only, or at least predominantly. Vowels are absent, or only partially or optionally noted. The term comes from Arabic script, in which the first four letters are a (really a glottal stop, not strictly a vowel), b, j and d. The term was coined in 1990, along with abugida, to distinguish from alphabets.

abugida – a writing system which represents consonants and vowels combined as one unit; between an alphabet and a syllabic system. The term is derived from four letters of the Ethiopic script. Synonymous with alphasyllabary.

acrophonic – when the name of a letter begins with the letter itself, as in Greek: alpha, beta, etc.

alphabet – technically used for writing systems that have separate symbols for consonants and vowels, in contrast with an abjad (consonants only) or an abugida (consonant-vowel combinations).

alphasyllabary – a writing system in which the symbols represent consonants, with a secondary (inherent) vowel. Distinct from a syllabary, the consonants in an alphasyllabary remain visually consistent even as the vowel changes (see Cree syllabics).

ascender – the portion of a letter that extends above the topline.

baseline – in type design and calligraphy, the imaginary line on which letters sit. Some writing systems, notably Arabic, do not employ a baseline but align letters relative to one another. Other systems rely instead on a headline or midline.

boustrophedon – writing that runs back and forth across a page or other surface. The term comes from ancient Greek, describing an ox tilling a field.

Brahmic – a script family descended from ancient Brahmi, predominant in South Asia.

consonantal – writing systems that have only consonant sounds, such as Phoenician; synonymous with abjad.

cursive – a style of writing in which all letters are connected.

descender – the portion of a letter that extends below the baseline.

diacritic – a smaller mark added to a letter to alter its pronunciation in some way. In the Latin alphabet, diacritics include marks separate from letters (such as an umlaut, used in German with a u, for example: ü) as well as marks affixed to letters (the cedilla attached to an s in Turkish to make the sh sound: ş).

digraph – two letters written together to form a single phoneme (sound). In English, ph is a digraph for the f sound.

fricative – a consonant pronounced with friction between parts of the mouth. The ch in the Scottish pronunciation of loch is a fricative formed by friction between the back of the tongue and the throat; the th in English is also a fricative, between the tongue and teeth.

grapheme – a letter or combination of letters that represent a single sound. In English f and ph are both graphemes.

headline – in type design and calligraphy, an invisible guideline running along the tops of letters. In Devanagari and related scripts, the headline, called a matra, is visible and connects the tops of letters.

Indic – the family of scripts descended from ancient Brahmi; synonymous with Brahmic.

logogram – a symbol that represents an entire word. Types of logograms include pictograms – symbols that depict a word in a graphic way, as the Chinese人 means 'person' – and ideograms, more abstract representations of a word or concept, such as $ standing for American dollars.

logographic – writing systems in which symbols stand for a whole word. Ancient Egyptian hieroglyphics is the oldest known logographic system; Chinese is the longest continuously in use.

majuscule – upper-case (or capital) letter.

mater lectionis – literally 'mother of reading', a consonant symbol that doubles as a long vowel, seen mostly in Hebrew and Arabic.

midline – in type design and calligraphy, the invisible horizontal line through the middle of letters, ensuring even proportion above and below.

minuscule – lowercase letter.

pangram – a sentence that uses every letter of an alphabet (or other writing system) at least once. The typical English example: The quick brown fox jumps over the lazy dog. A perfect pangram uses each letter once and only once (essentially an anagram of the alphabet). Also called an abecedarian or holoalphabetic sentence.

phonogram – a symbol that represents a sound; that is, a letter. Contrast with a logogram and Chinese characters.

phoneme – a single sound. Writing systems may use one letter or several to write a phoneme: the Greek letter φ is the equivalent of English ph or f, for example.

phonetic – writing systems in which each symbol represents a single sound, with no redundancy. Classical Arabic is phonetic; English, which has many ways to spell the same sound (f and ph, for instance), is not phonetic.

rebus – words or syllables represented by pictures of objects, the names of which have a given sound. In English, a drawing of an eye can represent I, for example. Rebuses were used to expand the meaning of early Chinese logograms.

schwa – a neutral, unstressed vowel, midway between short a and e; the phonetic symbol is ə.

script – a set of letter forms for writing a given language (alphabet, abjad, etc.).

stylus – a tool for marking a writing surface directly, rather than dispensing ink.

syllabary – a writing system in which the letters stand for a syllable, that is, a consonant plus a vowel. Unlike in an alphasyllabary (abugida), a syllabary has no consistent pattern. The Japanese kana sets are syllabaries: ka does not resemble ki or ko, even though they share the same consonant. The word syllabary can also refer to the table of syllabic letters, usually presented as a large grid.

trigraph – three letters written together to form a single phoneme (sound). In English, tch represents a single sound.

CONTRIBUTORS' BIOS

Zhamsoev Amgalan The calligrapher of the Ulzei workshop in Russia's Republic of Buryatia, which works to arouse interest in the vanishing Buryat language among the Buryat people and foreigners through Mongolian calligraphy.

Yukiko Ayres Yukiko Ayres became an apprentice of Koushou Yashiro, who is Meikaku Kusakabe's (a founder of modern Japanese calligraphy) great-grand apprentice. A member of the Nihon Shodouin calligraphy association, she reached Doujin, the level above Shihan (master) at age 26.

Xueyi Bai Xueyi Bai is a Chinese calligrapher based in the Blue Mountains near Sydney, Australia. Born in Shanghai, she has been a member of the Chinese Calligraphers' Association since 1992 with her work featured in major national exhibitions, and taught calligraphy for 12 years in the Shanghai Children's Palace. Xueyi teaches at the Art Gallery of NSW and Blue Mountains Cultural Centre.

Oleksiy Chekal Oleksiy Chekal is a Ukranian designer, calligrapher, art historian, art director studio PanicDesign, and Professor in Florence Classical Arts Academy. He uses both Latin writing and the Greek-Cyrillic world of texts and letters.

Randal M Hasson Studio Randall M Hasson is an artist, calligrapher, instructor and speaker who has appeared on the faculty of Arts, Lettering Arts, and at conferences in the US, Canada and England.

Elinor A Holland Elinor A Holland is a calligrapher of Arabic and Latin scripts. She received her *Ijaza*, or diploma, in two forms of Arabic script in 2013 from Master Calligrapher Mohamed Zakariya. She teaches regularly for the NY Society of Scribes and colleges, art centres and museums in the US and Canada including the Metropolitan Museum of Art, the American Museum of Natural History and The Smithsonian Institute and has exhibited worldwide.

Kristian Kabuay Kristian is an artist/entrepreneur specialising in endangered writing systems from the Philippines. Kristian has spoken around the world at museums, schools, and companies. Visit Kabuay.com for more information.

Patty Leve Patty Leve is a Hebrew and English calligrapher who has been making *ketubot*, Jewish marriage contracts, for almost forty years. She studied graphic design and earned a BFA from Cooper Union in New York City.

Ann Miller Ann Miller is a San Francisco Bay Area artist and designer who teaches design with a special emphasis on calligraphic invention and spatial concepts. She studied with Nathan Oliveira and Richard Diebenkorn and received AB and Master of Arts degrees with distinction from Stanford University.

Pradnya Naik Pradnya Naik is a designer specialised in Indic Typography, Type Design, Lettering and Calligraphy currently based in Bangalore, India. She has collaborated with Indian Type designers and typographers. Pradnya has taught calligraphy, typography and type design at various design schools in India. www.pradnyanaik.com.

Zora O'Neill Zora O'Neill is the author of the award-winning memoir *All Strangers Are Kin* (2016), about studying Arabic and travelling in the Middle East.

Moulid Nid ouissadan Moulid Nid ouissadan is a poet and calligrapher who comes from Taliouine, the capital of saffron. He draws inspiration from his culture, and has exhibited at many galleries, cultural institutions, international festivals and so on while working in a Tifinaghe calligraphy workshop in Morocco.

Sorravis Prakong Based in Bangkok, Sorravis Prakong began to work on lettering design and calligraphy in 2013, and later became interested in calligraphy combined with street art (Calligraffiti).

BIBLIOGRAPHY AND THANKS

Jyotish Sonowal Jyotish Sonowal is a multidisciplinary designer and UX strategist. He specialises in native Indian scripts typeface design, including Bangla, and has fonts on Google Fonts.

Serey Sot Serey Sot is a freelance illustrator and graphic designer based in Phnom Penh, Cambodia.

Molly Suber Thorpe Molly Suber Thorpe is a hand lettering artist based in Athens, Greece. She teaches Skillshare classes and in-person workshops, and is the bestselling author of three books about calligraphy. Molly has been featured in *The Guardian, The Wall Street Journal, Martha Stewart Weddings*, and *The Los Angeles Times*. Her client list includes Martha Stewart and Fendi.

Bibliography

As with languages, scripts are fluid creations, varying from region to region, era to era, and style to style. The references here should be considered jumping off points for going more in depth. These works were helpful in preparing this book; they also provide much more detail on certain aspects of language and writing.

The Atlas of Languages: The Origin and Development of Languages Throughout the World. Bernard Comrie, Stephen Matthews and Maria Polinsky, eds. London: Bloomsbury, 1996. A colourful overview, focussing on spoken language more than writing.

The World Encyclopedia of Calligraphy: The Ultimate Compendium on the Art of Fine Writing: History, Craft, Technique. Christopher Calderhead and Holly Cohen, eds. New York: Sterling, 2011. Delves deep into writing as an art form, with excellent examples.

The World's Writing Systems. Peter T. Daniels and William Bright, eds. New York: Oxford University Press, 1996. More technical, geared for linguists, detailing how each script functions.

A History of Writing. Fischer, Steven R. London: Reaktion, 2001. General background, in some academic detail.

Thanks to:

Charles Riley (N'ko and Vai)
Peter Fremlin (Bengali)
Lameen Souag (Tifinagh)
Coleman Donaldson (N'ko)
Tombekai V. Sherman (Vai)
Liang Hai (梁海), 孟和吉雅 (Menghejiya) and 青柏 (Qingbai) (Mongolian)
Gerald Roche (Tibetan)
Jamra Patel Design Studio
Learn Thai Podcast
And to Simon Ager and his website Omniglot (www.omniglot.com), a truly amazing compendium of the world's languages and scripts.

THE ART OF LANGUAGE

Printed in Singapore
ISBN 978 1 78868304 3
© Lonely Planet 2019
© artists as indicated 2019

The Art of Language
November 2019
Published by Lonely Planet Global Limited
CRN 554153
www.lonelyplanet.com
10 9 8 7 6 5 4 3 2 1

Managing Director, Publishing Piers Pickard
Associate Publisher Robin Barton
Art Director Daniel Di Paolo
Designer Tina García
Editor Nora Rawn
Print Production Nigel Longuet

Contributors

Written by Zora O'Neill. Calligraphy by Zhamsoev Amgalan, Yukiko Ayres, Xueyi Bai, Oleksiy Chekal, Randal M Hasson Studio, Elinor Holland, Kristian Kabuay, Patty Leve, Ann Miller, Pradnya Naik, Moulid Nid ouissadan, Sorravis Prakong, Jyotish Sonowal, Serey Sot, Molly Suber Thorpe.

Although the authors and Lonely Planet have taken all reasonable care in preparing this book, we make no warranty about the accuracy or completeness of its content and, to the maximum extent permitted, disclaim all liability from its use.

All rights reserved. No part of this publication may be reproduced, stored in a retrieval system or transmitted in any form by any means, electronic, mechanical, photocopying, recording or otherwise except brief extracts for the purpose of review, without the written permission of the publisher. Lonely Planet and the Lonely Planet logo are trademarks of Lonely Planet and are registered in the US patent and Trademark Office and in other countries.

Lonely Planet Offices

Australia
The Malt Store, Level 3,
551 Swanston St, Carlton, Victoria 3053
T: 03 8379 8000

Ireland
Digital Depot, Roe Lane (off Thomas St),
Digital Hub, Dublin 8,
D08 TCV4

USA
155 Filbert St, Suite 208,
Oakland, CA 94607
T: 510 250 6400

Europe
240 Blackfriars Rd,
London SE1 8NW
T: 020 3771 5100

STAY IN TOUCH lonelyplanet.com/contact

MIX
Paper from responsible sources
FSC C021741

Paper in this book is certified against the Forest Stewardship Council™ standards. FSC™ promotes environmentally responsible, socially beneficial and economically viable management of the world's forests.